IMAGES
of America

BEVERLY HILLS
1930–2005

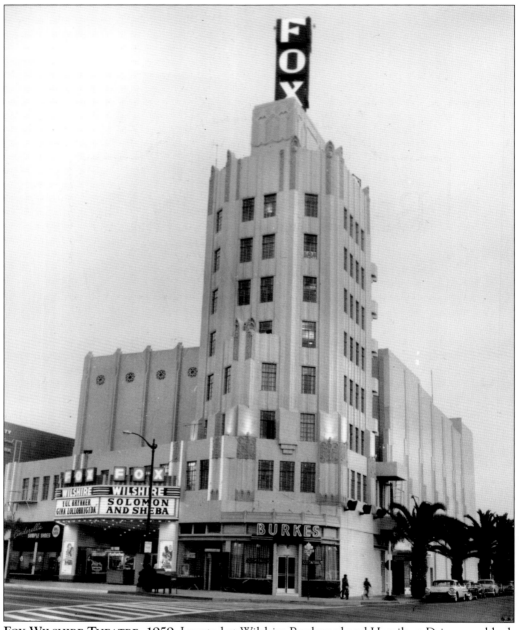

Fox Wilshire Theatre, 1959. Located at Wilshire Boulevard and Hamilton Drive, one block east of La Cienega, the Fox Wilshire remains as one of Beverly Hills historic theatres.

On the Cover: The Beverly Theater, 1945. Located on the northeast corner of Beverly Drive and Wilshire Boulevard, the Beverly became an iconic landmark known worldwide.

IMAGES
of America

BEVERLY HILLS
1930–2005

Marc Wanamaker

ARCADIA
PUBLISHING

Published by Arcadia Publishing
Charleston SC, Chicago IL, Portsmouth NH, San Francisco CA

Printed in the United States of America

Library of Congress Catalog Card Number: 2006924388

For all general information contact Arcadia Publishing at:
Telephone 843-853-2070
Fax 843-853-0044
E-mail sales@arcadiapublishing.com
For customer service and orders:
Toll-Free 1-888-313-2665

Visit us on the Internet at www.arcadiapublishing.com

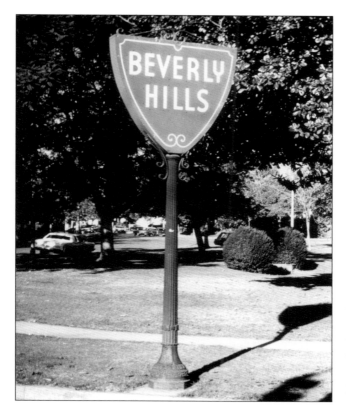

THE BEVERLY HILLS SHIELD SIGN, 1964. The shield signs were placed at the city limits during the 1930s, giving Beverly Hills its own identity as an island within the city of Los Angeles.

CONTENTS

ACKNOWLEDGMENTS

This volume of Beverly Hills historical information was the result of collecting photographs and memorabilia for over 30 years. The Beverly Hills Historical Society was formed by Winston Millet in 1983. It was incorporated in January 1984 during the city's 70th anniversary. I joined the historical society as its archivist, collating Millet's semi-comprehensive collection of photographs and information on the history of Beverly Hills. The information and photographs contained in this volume are from Bison Archives, an historical archive of Southern California and Los Angeles–area research materials, which includes the development of the motion picture and television industries in the United States.

Bison Archives was formed in 1971 during the process of researching historical data on the motion picture studios in the United States for an encyclopedic history. The archive was compiled from thousands of sources of photograph and research materials, particularly from motion picture studios' research libraries and film location files that the studios have been collecting since 1915. Many of the photographs in this book have never been published. They are a historical record of Beverly Hills streets, estates, buildings, and landmarks.

I wish to thank the many institutions and individuals over the years that helped with the collection of research on the history of Beverly Hills. This book is dedicated to the Beverly Hills Historical Society and other important contributors to the research of Beverly Hills. Some of these contributors include Jill Tavelman Collins, president of the Beverly Hills Historical Society, whose father was a Beverly Hills pioneer in his own right, having owned and operated Tavelman's, one of the more prominent clothiers in Beverly Hills history; Robert S. Anderson, whose family built and operated the Beverly Hills Hotel in its early days; Phyllis Lerner, past president of the historical society; Winston Millet, founder of the society; Jeff Hyland, real estate historian; Elinor Quinlan, whose father built the Beverly Theater; Fred E. Basten; Alan Bunnage; Ira Goldberg; Marty Geimer; the Beverly Hills Parks and Recreation Department; and the Beverly Hills Public Library. Some of the historical source materials were researched in Pierce E. Benedict's *History of Beverly Hills*, *Beverly Hills Citizen* newspaper of 1947, and the voluminous research files of Bison Archives.

INTRODUCTION

This volume is the second of two, beginning with *Early Beverly Hills*. The first volume dealt with Beverly Hills from 1880 to 1940. This area of Los Angeles was first explored in 1769. Beverly Hills was founded in 1906, and little appreciable human history occurred in the intervening 137 years. By 1896, however, the railroad had arrived, bringing eager settlers to "Morocco," the name of the station and area that was to follow the Los Angeles development boom of the late 19th century. In 1906, the Rodeo Land and Water Company was formed and was guided by oilman Burton E. Green with Charles Canfield, Max Whittier, Frank Buck, Henry Huntington, and W. G. Kerckhoff. They had tried to drill for oil under Amalgamated Oil Company, but found water instead, resulting in a change of business from oil to land development.

Plans for the new development were mapped out by New York landscape architect Wilbur Cook in 1906. In January 1907, the name and development of Beverly Hills was officially recorded, covering lands between Santa Monica and the hills. The name "Beverly" was adopted by Green after the famed Beverly Farms in Massachusetts, where President Taft vacationed. The first house was built on Crescent Drive, and by 1912, the Beverly Hills Hotel was opened. In 1917, the first movie people arrived and invested in the first store in Beverly Hills. Film director Fred Niblo, Thomas Ince, and star Charles Ray were investing money in homes and a business, inspiring other Hollywood celebrities to come to Beverly Hills. By 1919, several famous movie stars began to move to the city, the most prominent being Douglas Fairbanks and Mary Pickford, who purchased a hillside estate and created the famed Pickfair. The serious start of the movie star migration to Beverly Hills was in 1922 with the arrival of such movie greats as Will Rogers, Charles Chaplin, Gloria Swanson, Tom Mix, Marion Davies, and Harold Lloyd.

During the Depression, Beverly Hills survived financial ruin due to its residents organizing the business community and maintaining the link directly to the motion picture industry, in which a large percentage of the city's residents were employed. Construction of the magnificent city hall began in 1931 and was followed by the fire station in 1932 and the post office in 1934. During the 1930s, the city became church oriented, building many churches in the area. By the 1950s, there was a large influx of Jews, who built synagogues and schools. In the 1970s, the bulk of the 21st century's Persian population became residents. The Beverly Hills Civic Center was reconstructed in 1988, adding a new fire station, police department, and library.

With the coming of the new millennium, the city of Beverly Hills continued its renewal again, demolishing some if its more important historic sites while saving others. With the coming of the 2000s, there was a renaissance of development and renewal resulting in the widening of streets and making the city businesses friendly while rejuvenating Beverly and Rodeo Drives.

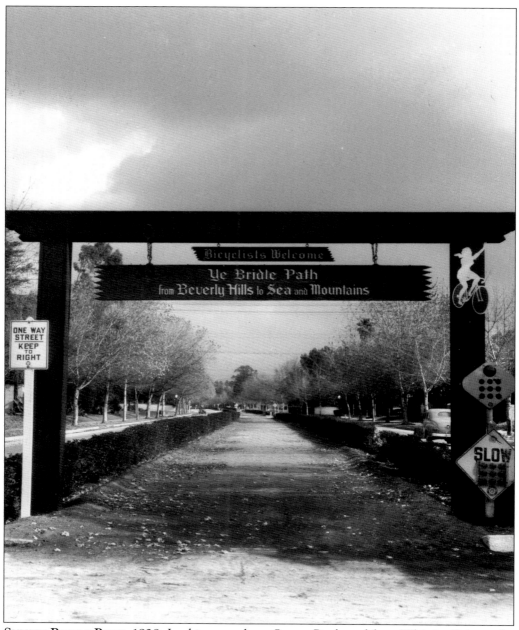

SUNSET BRIDLE PATH, 1938. Looking east down Sunset Boulevard from Whittier Drive is the Sunset Bridle Path. By 1938, with less horses in the city limits of Beverly Hills, the bridle path became more of a bicycle path, keeping the small-town feeling of the town well into the 1950s.

One

THE DEPRESSION YEARS
1930–1940

According to Pierce E. Benedict's *History of Beverly Hills* of 1934, there were "5,324 buildings in the city of which 5,033 were residences and 291 business structures. There were 96 miles of paved streets, each lined with trees."

The 1930s saw some limited development with the opening of the new Beverly Hills City Hall in April 1931, and with the help of the motion picture industry, the construction of three theaters within the city limits—the Regina, the Fox Wilshire, and the Warner Beverly Hills—created a sense of optimism in opposition to the "hard times" ahead. The Beverly Hills School Board and local residents had succeeded in passing a state law that allowed the City of Beverly Hills to take over the administration of Beverly Hills High School. In the early 1930s, the police department consisted of Chief Charles C. Blair (who acted as both police chief and fire chief), a police captain, three lieutenants, four sergeants, four motorcycle officers, 23 patrolmen, and three clerks—a total of 39 personnel. The groundbreaking for the Beverly Hills Post Office was held on February 27, 1933. The site formerly was occupied by the old Pacific Electric Railway station and the Sun Lumber Company, two of Beverly Hills's oldest landmarks at the time. The Beverly Hills Post Office opened for business on April 28, 1934, due to the efforts of Will Rogers.

Beautification of Beverly Hills continued throughout the 1930s, with the first electric fountain built in 1930 on land donated by the Rodeo Land and Water Company at the intersection of Santa Monica and Wilshire Boulevards. Life went on in the parks with the lawn bowling leagues and swimming, tennis, and baseball teams utilizing the La Cienega and Roxbury parks.

Civic activities highlighted life in the city, with Will Rogers hosting the first chamber of commerce banquet held in the newly built city hall in 1932. Movie premieres continued to be held at the Beverly Hills theaters and were attended by local movie celebrities. The Beverly Hills Brown Derby restaurant opened in 1931 and became one of the most popular sites that celebrities and residents alike frequented.

The business community banded together and promoted an advertising campaign touting Beverly Hills as the home of "specialty" stores where people could "window shop," a commonplace leisure activity along New York's Fifth Avenue. Beverly Hills was gaining a reputation as "show window of the world."

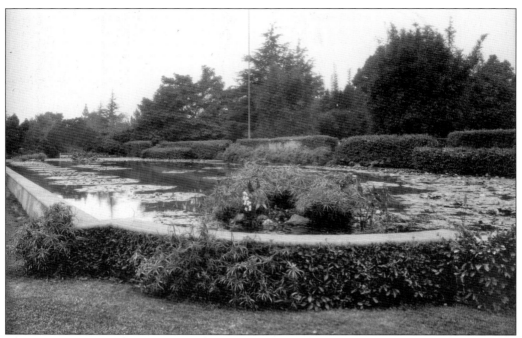

BEVERLY GARDENS PARK, 1930. Here is a view of the lily pond, installed in 1907 between Beverly and Canon Drives, that became a Beverly Hills landmark.

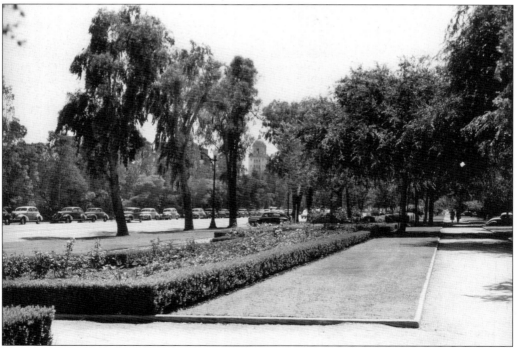

BEVERLY GARDENS PARK, 1938. Pictured looking west down Santa Monica Boulevard, the gardens acted as both a buffer zone between the business and residential districts and as a city park that spanned from Whittier Drive to the west and Doheny Drive to the east.

WILL ROGERS MEMORIAL PARK, 1952. Known as Sunset Municipal Park since its construction in 1912, the park was a favorite of nearby resident Will Rogers who spent many hours there with his family. In 1952, the city wanted to further recognize and pay tribute to Rogers, who died in a plane crash in 1935. The park was renamed Will Rogers Memorial Park to memorialize one of Beverly Hills's most beloved residents.

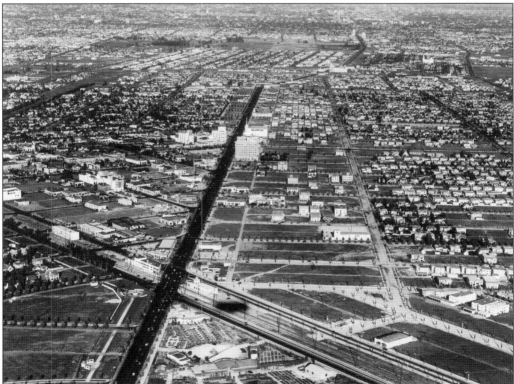

BEVERLY HILLS, 1935. Looking east from the intersection of Santa Monica and Wilshire Boulevard, the downtown corridor was in a state of suspension during the Depression. The Beverly Wilshire Hotel, the California Bank Building, the Beverly Theater, and the Warner Beverly Hills Theater were the only prominent structures on Wilshire Boulevard during the 1930s.

11

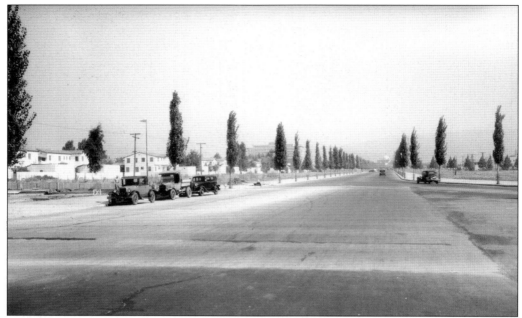

BEVERWIL AND OLYMPIC, 1933. Looking north, this is Beverly Drive from Olympic at the beginning of the Great Depression. Much of the residential development south of Wilshire was underway at the end of the 1920s on both sides of south Beverly Drive. With the coming of the 1930s, much of the proposed construction of a commercial section was postponed until after the Depression.

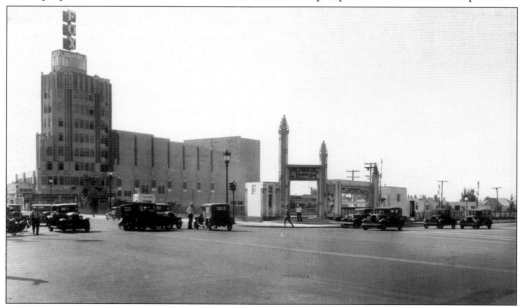

WILSHIRE AND LA CIENEGA, 1934. The Wilshire Links miniature golf course was once located on the southeast corner with the Fox Wilshire Theater, a block east at Hamilton Drive. In 1972, Great Western Savings opened its new Beverly Hills headquarters on the site in a dramatic oval-shaped building crowned with a large bronze sculpture of John Wayne on horseback in the forecourt.

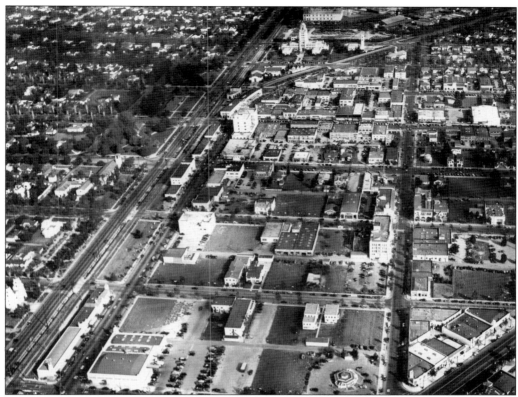

BEVERLY HILLS BUSINESS TRIANGLE, 1937. Looking east with Santa Monica Boulevard at left, Brighton Way is in the center and Wilshire at the right. Note that many of the present-day commercial streets such as Beverly Drive and Rodeo Drive still had single-family homes on them during the 1930s, when development was in suspension until better times.

BEVERLY WILSHIRE HOTEL, 1937. Opened in 1928, the Beverly Wilshire was only the second major hotel to open in Beverly Hills since 1912 when the Beverly Hills Hotel was built. When this photograph was taken, the beginning of the Beverly Hills recovery was underway, with new development on the Wilshire corridor giving the hotel a new lease on life by the end of the 1930s.

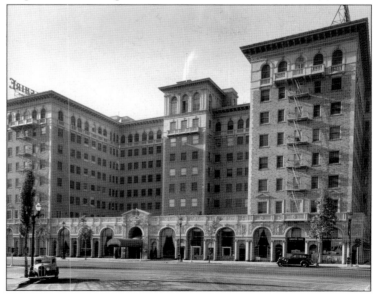

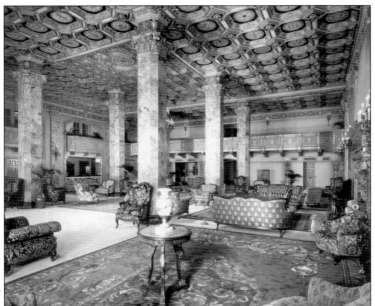

BEVERLY WILSHIRE HOTEL, 1937. The interior design of the lobby was in the Spanish Colonial Revival style with marble columns, floors, an ornate coffered ceiling, and antique furnishings. Once an elegant European-styled hotel, it was remodeled several times over the years. In 1961, hotelier Hernando Courtright purchased the hotel, and by 1971, he had added the Beverly Wing and completely modernized the entire hotel.

BEVERLY DRIVE AND WILSHIRE BOULEVARD, 1938. Looking south at the intersection of Beverly Drive and Wilshire Boulevard, one can see the Beverly Wilshire Hotel in the center of the photograph. A closer look at the streets in the vicinity reveals empty lots on north and south Beverly Drive, Crescent Drive to the left, and Rodeo Drive on the right.

WILSHIRE AND BEVERLY DRIVE, 1939. The intersection of Wilshire and Beverly Drive has always been the heart of the commercial triangle of Beverly Hills. On the northeast corner was the Beverly Theater, built in 1925. It was the city's first theater. On the northwest corner was the parking lot for Adrian's Couture building, which was originally Victor Hugo Restaurant in the 1930s.

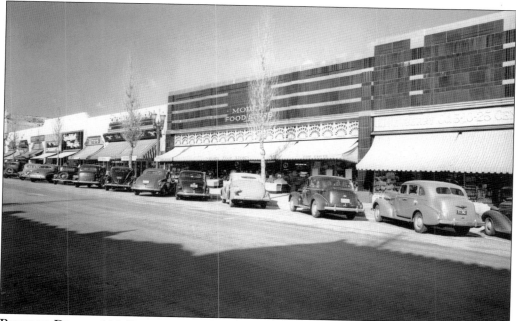

BEVERLY DRIVE, 400 BLOCK, 1939. The east side of Beverly Drive between Santa Monica Boulevard and Brighton Way is pictured here in 1939. By the end of the 1930s, Beverly Hills was well on its way to economic recovery with new stores and services rejuvenating a once stagnant business community. At this time, these Beverly Drive stores included J. J. Newberry, Model Food Store, Owl Drug Company, Sport Shop, Toy Shop, and Beverly Mode Shop.

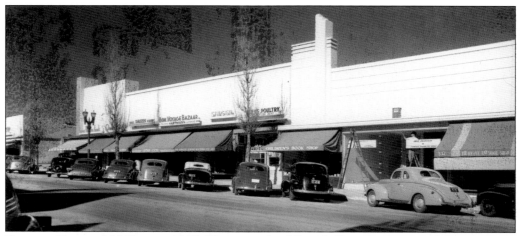

BEVERLY DRIVE, 300 BLOCK, 1939. The east side of Beverly Drive's commercial district shows such stores as The Weave and Wool Shop, Children's Book Shop, Poultry Shop, Singer Shop, Bon Voyage Bazaar Luggage, and Drizen Shoes, among others.

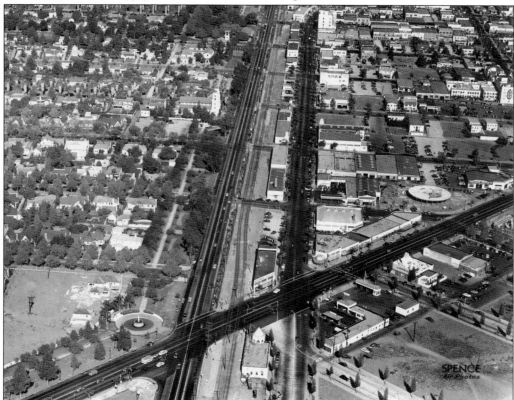

WILSHIRE AND SANTA MONICA BOULEVARDS, 1940. This photograph looks east on Parkway along Santa Monica Boulevard from Wilshire Boulevard during the Beverly Hills development boom. Intersecting the photograph is South Santa Monica Boulevard in the center. At bottom left is the Wilshire Electric Fountain, and at the right can be seen the construction of the new Simon's Drive-In restaurant at Linden Drive and Wilshire Boulevard.

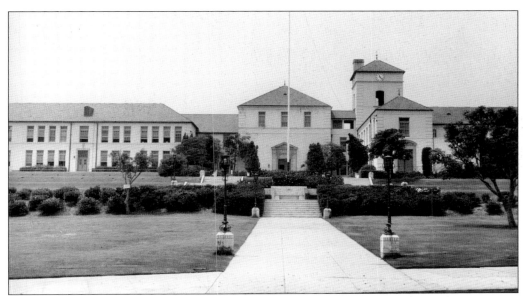

BEVERLY HILLS HIGH SCHOOL, 1950. In 1957, Beverly High School celebrated its 30th anniversary. The 1950s saw a continued expansion of school facilities, including additional classrooms and a new athletic field.

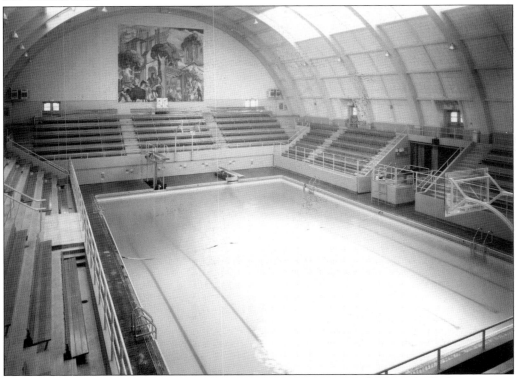

BEVERLY HILLS HIGH SCHOOL SWIMMING POOL, 1940. In 1946, the Beverly High swimming pool was immortalized in the classic film, *It's a Wonderful Life,* showing off the unique, $120,000 pool cover that electrically converted the pool area for basketball use.

BEVERLY HILLS HIGH SCHOOL AUDITORIUM, 1930. In the fall of 1930, the fight to take over the high school administration from the Los Angeles School Board began. Only after the local citizens had secured passage of a state law did the campaign prove successful. On July 1, 1935, the local school board took over jurisdiction of the high school.

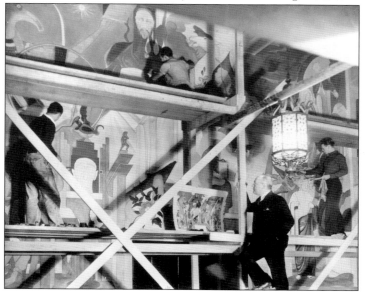

EL RODEO SCHOOL MURAL, 1934. Famed artist and movie art director Hugo Ballin designed and painted a major mural for the lobby of the school. The mural project was part of the Public Works Art Project and was completed on February 14, 1934. Entitled *School Days*, the mural was one of only a few public murals in the city's entire history.

Two

YEARS OF RECOVERY
1937–1945

The publicity campaign to keep business alive in Beverly Hills throughout the Depression years was beginning to work, creating a "glamour" surrounding the shopping district as well as in the real estate sector. With the help of the motion picture business and the numerous celebrities as residents, Beverly Hills had a reputation as being a city of quality. Due to its movie star clientele, the Beverly Hills Brown Derby, by the end of the 1930s, was almost as famous as the Hollywood Derby. On any given day or night, one could see Tom Mix, Al Jolson, Eddie Cantor, Charles Chaplin, Buster Keaton, Mary Pickford, and Douglas Fairbanks mixing with the regular customers. By 1936, radio station KMPC had become a fixture along Wilshire Boulevard, its towers a Beverly Hills landmark known as "the station of the stars." At the beginning of the Depression, the Beverly Hills Hotel closed its doors from lack of financial support. By 1933, the hotel had a new owner and was remodeled and decorated. Temple Emanuel, the Reform temple in Beverly Hills, was founded in 1938 for a growing Jewish population. Nearby Christian church congregations also were growing steadily.

As the 1930s were coming to an end, the Beverly Hills Police Department was recognized by government officials as being "without equal in the country." The fire department also was appreciated as a high quality organization that showed off its beautiful fire engines periodically to the town's residents. In 1937, the Music Corporation of America (MCA) built a classically designed building complex at Burton Way and Rexford Drive, bringing to Beverly Hills one of the most important entertainment agencies in the country.

The period leading up to World War II was a time of recovery from the Depression. With the attack on Pearl Harbor at the end of 1941, Beverly Hills entered the fight. Two draft boards were opened, a USO unit was organized, and the Red Cross headquartered itself in the city hall tower. Longtime Beverly Hills resident Mary Pickford took the lead and helped organize a radio program from her home, Pickfair, and hosted many fund-raising parties there. The Beverly Wilshire Hotel became the official air raid shelter.

At the end of the war, the Christmas lights once again were turned on, and the stores began to see a sales boom growing.

BEVERLY HILLS CITY HALL, 1944. The city hall building's two wings housed the city council chambers and the city courthouse, along with the fire and police departments. During the war, the city organized a serviceman canteen that offered free meals, entertainment, and an assortment of services.

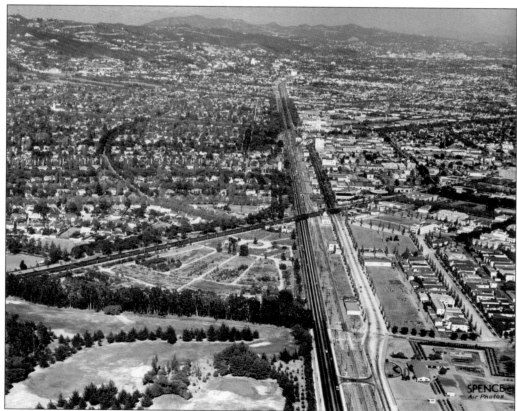

NORTHWEST BEVERLY HILLS, 1945. This is the intersection of Santa Monica and Wilshire Boulevard as seen from the eastern edge of the Los Angeles Country Club. The triangular corner in the center was the site of the Beverly Hills Nursery and later the Beverly Hilton Hotel in 1955.

BEVERLY DRIVE, 1945. This photograph looks north from the onion-domed roof of the Beverly Theater at Wilshire and Beverly Drive. The Adrian Couture building across the street, originally Victor Hugo Restaurant, became the famous Lane Bryant women's clothing department store at 233 North Beverly Drive in the 1950s.

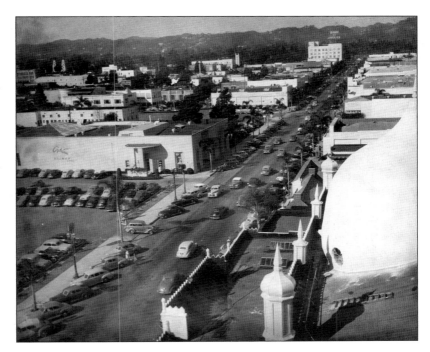

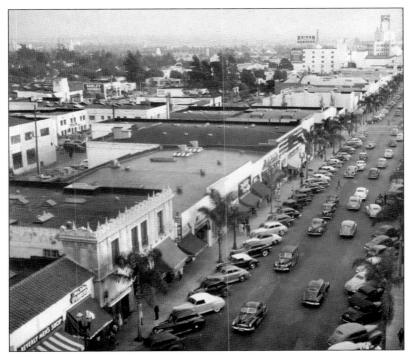

BEVERLY DRIVE, 1945. From the roof of the Bank of America building, this view looks south down Beverly Drive. The growth of the commercial triangle resumed after World War II with a new economic boom in Beverly Hills. Many various specialty stores developed during the Depression years; new residents were swelling the population dramatically at this time.

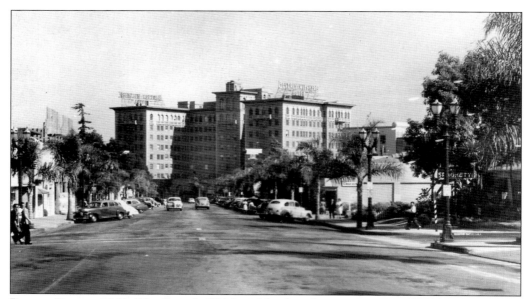

RODEO DRIVE, 1941. The Beverly Wilshire Hotel at the intersection of Wilshire Boulevard and Rodeo Drive could be seen for miles around. Rodeo Drive at this time was a combination of surviving bungalow homes, service buildings, and stores.

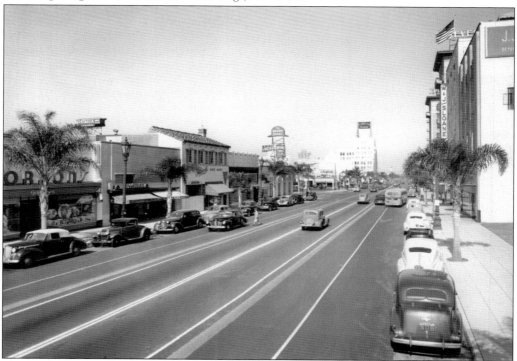

WILSHIRE BOULEVARD EAST, 1944. The Beverly Hills Brown Derby is visible at Rodeo Drive and Wilshire Boulevard across from the Beverly Wilshire Hotel. Some of the stores on Wilshire Boulevard just west of Rodeo Drive included Gordon's and Evans. On the south side of Wilshire Boulevard stood the J. J. Haggarty department store.

LYON VAN AND STORAGE COMPANY, 1948. Located at 9016 Wilshire Boulevard, the Lyon building has been a Beverly Hills Wilshire Boulevard landmark since 1941. The tower is a postmodern design, which merged the signage with the building's architecture. Next door was Harrison H. Rhoads Chevrolet, one of several automobile dealerships in Beverly Hills at this time.

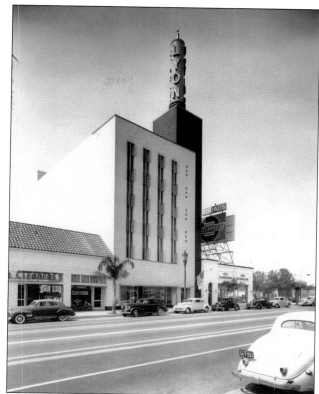

ASSOCIATED GASOLINE STATION, 1941. The flying "A" gas station was at 400 Rexford Drive. Located on the northeast corner of Rexford Drive across from the Beverly Hills City Hall, the station was built on a portion of the original Sun Lumber Company that once dominated the area. Today the gas station site location is the south wing of the Beverly Hills Public Library.

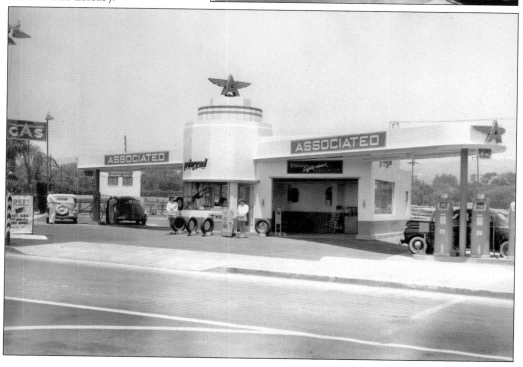

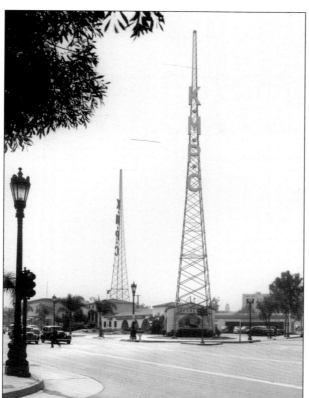

KMPC RADIO STATION, 1942. Located at Wilshire Boulevard and Camden Drive, the station has been a major Beverly Hills landmark since 1936. Known as the "Station of the Stars," KMPC was the one and only radio station in Beverly Hills history. The station, having to share its Mission-style property with an automobile service station, moved to Hollywood in 1943. In later years, the building was extensively remodeled and became an annex for Saks Fifth Avenue.

ROBERTSON AND BURTON WAY, 1940. Looking east on Burton Way to Robertson, the Pacific Electric dominated their right-of-way until the mid-1960s, when all rail traffic ceased. Beginning in the 1930s, apartment houses were constructed on both sides of the wide, east-west corridor, increasing the population of that area well into the 1970s.

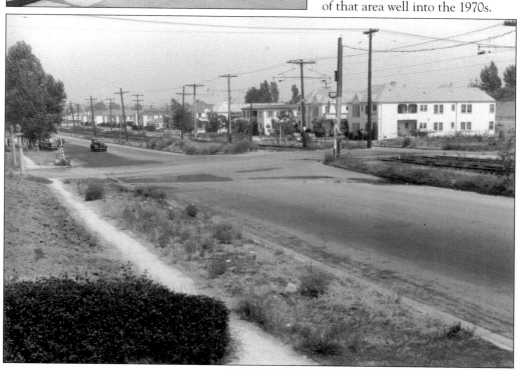

EAST ON BURTON WAY AT REXFORD DRIVE, 1944. The Pacific Electric railway tracks ran through Beverly Hills along what is now South Santa Monica Boulevard, stopping at the Canon Drive station for over 40 years. This photograph, taken from the roof of the fire station, shows the tree-lined boulevard of Burton Way.

EAST ON BURTON WAY AT DOHENY DRIVE, 1944. At this time, the intersection of Doheny Drive and Burton Way was just another residential street crossing with a small neighborhood market on the southeast corner.

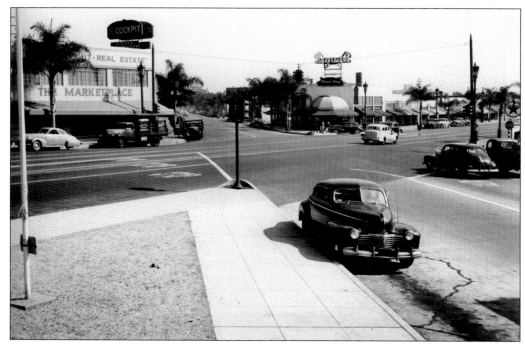

SOUTH SANTA MONICA AND WILSHIRE BOULEVARD, 1944. Looking east across Wilshire Boulevard there were two shopping buildings that were Beverly Hills landmarks—the Marketplace building with the Cockpit Steak House and real estate offices and the Whelan Drug Store building on the southeast corner.

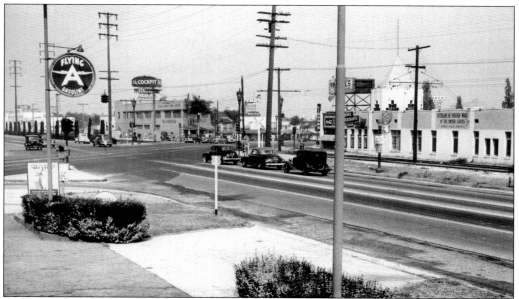

SANTA MONICA AND WILSHIRE BOULEVARDS, 1944. The flying "A" gas station on the northwest corner overlooked one of the most traveled intersections in the city of Beverly Hills. Across the street is the octagonal-pointed roof of the Wine Merchants building, a Beverly Hills architectural landmark to this day.

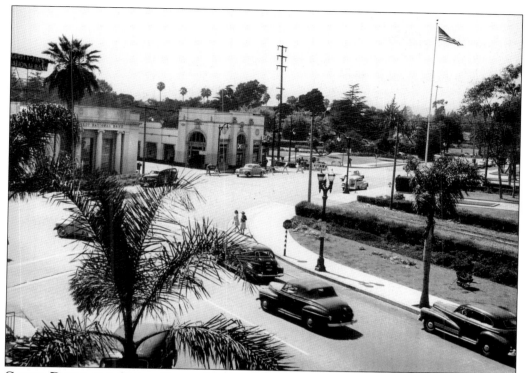

CANON DRIVE AND SOUTH SANTA MONICA BOULEVARD, 1944. On the southwest corner of Canon Drive and Santa Monica Boulevard was the Pacific Electric railway station. Built in 1934, it would later be moved across the street to make way for the new Beverly Hills Post Office.

ADRIAN'S COUTURE SHOWROOM, 1942. The Adrian building at 233 North Beverly Drive was once the famed Victor Hugo Restaurant of the 1930s. Adrian was a celebrated film costume designer of the 1920s–1930s, and he established a couture business that was directly connected to the film industry and its marketing business. The building later became the Lane Bryant department store for women's clothing in the 1950s.

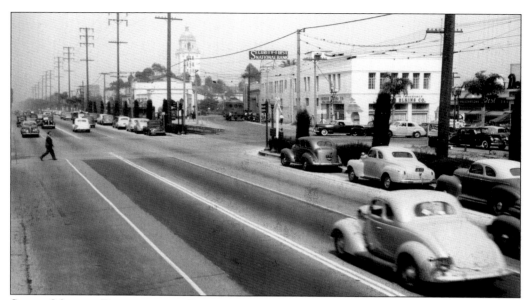

SANTA MONICA BOULEVARD AT BEVERLY DRIVE, 1944. The city hall and train station can be seen at the top center across from the Security-First National Bank. The Pacific Electric streetcars and freight trains shared the rail system that ran through Beverly Hills.

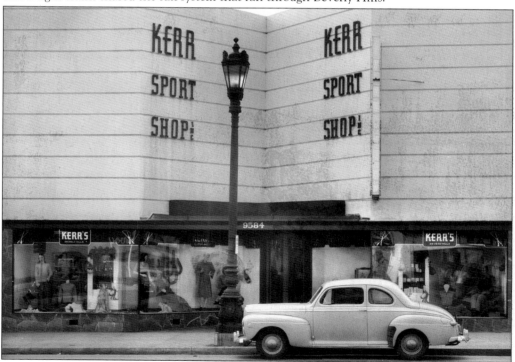

KERR SPORT SHOP, 1945. Located at 9584 Wilshire Boulevard, Kerr Sport Shop was one of Beverly Hills's most enduring businesses well into the 1960s. Established by A. H. Kerr, the store stocked ammunition, guns, fishing tackle, golf, tennis, boats, athletic equipment, barbecues, and badminton supplies as well as sportswear and cameras.

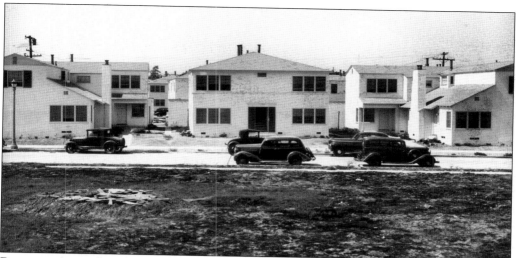

POSTWAR APARTMENTS, 1945. Beverly Hills apartments built after World War II were a part of the boom of development that created new neighborhoods in the Beverly Hills area south of Olympic Boulevard.

SUNSET MUNICIPAL PARK, 1941. Originally a part of the Beverly Hills Hotel property installed in 1912, the park was later given to the City of Beverly Hills by Mrs. Anderson, the builder and operator of the hotel. Sunset Park, the oldest in the city, was officially renamed Will Rogers Memorial Park in 1952.

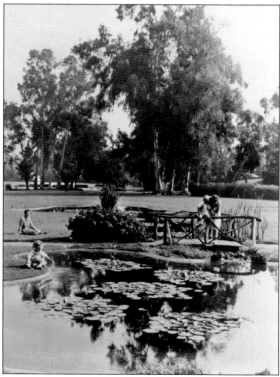

COLDWATER PARK, 1940. The original site of Coldwater Park is where underground waters from Franklin and Coldwater Canyons meet. Since the early days of the ranchos, the artesian wells in the foothills of the Santa Monica mountains were called "the meeting of the streams," which later translated into Rancho Rodeo De Las Aguas. Visible at the top right of the photograph is the Thorkildsen (and later the Kirk Johnson) mansion, overlooking the park.

COLDWATER PARK, 1930. The park was established at the mouths of Franklin and Coldwater Canyons in the early 1920s. Eucalyptus trees, ponds, grassy lawns, and picnic areas were landscaped into the park area off the main road of Coldwater Canyon Boulevard. In 1949, the Native Daughters of the Golden West commemorated a plaque in the park honoring where the name Rodeo De Las Aguas came from—the gathering of the waters.

Three

POSTWAR BEVERLY HILLS
1946–1950

The war years in Beverly Hills were a time of activism, mobilizing the celebrity residents into action by selling war bonds, hosting soldiers, and raising money for the Red Cross and other relief organizations. At every event that took place in the city during the war, the press covered the "war related" aspects of what normally would have been just a Hollywood-style event highlighting the movie stars and their films.

By 1947, a new boom began to emerge. The *Beverly Hills Citizen* newspaper came out with "25th Year of Progress Edition . . . 1947," highlighting the history and future of Beverly Hills as a community and its past and present development. The newspaper's special edition highlighted profiles of longtime Beverly Hills businesses, civic groups, and government milestones. Some of these included the following: the 25th year of the *Beverly Hills Citizen* newspaper, Beverly Hills Camera Store, Girl Scouts of Beverly Hills, Beverly Hills Athletic Club, Red Cross of Beverly Hills, The Market Place food store, W&J Sloane Store, Tavelman's Clothiers, Beverly Hills Transfer and Storage Company, Haggarty's Department Store, Candy Lane, Boy Scouts of Beverly Hills, Kiwanis Club, The Beverly Hills Hardware Company, Saks Fifth Avenue, Rotary Club, Beverly Toy Shop, R. A. Harris 5&10 Cent Store, Beverly Hills Post Office, All Saints' Episcopal Church, Beverly Hills Community Presbyterian Church, First Church of Christ, Scientist, Church of the Good Shepherd, Beverly Hills Lutheran Church, Temple Emanuel, Lyon Van and Storage, Beverly Hills Premier Market, Dean Witter and Company, Gunther Drug Company, Security-First National Bank, California Bank, National Bank and Trust Company, Merrill Lynch, Bank of America, Beverly Hills Brown Derby, Pierce Brothers Mortuary, Payne Furnace Company, Schwab's Pharmacy of Beverly Hills, Beverly Hills Bowling Courts, Warner Beverly Hills Theater, Fox Wilshire Theater, Beverly Theater, Regina Theater, The Tropics, Mama Weiss' Csarda Hungarian Restaurant, Hillcrest Motor Company, I. Magnin and Company, London Shop, and the Beverly Hills Chamber of Commerce.

One of the first and most important development projects was announced in 1950 by Conrad Hilton. His company filed an application for a $17 million hotel to be built on the former site of the Beverly Hills Nursery at the intersection of Santa Monica and Wilshire Boulevard.

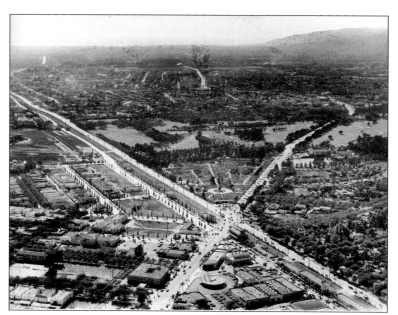

BEVERLY HILLS CROSSROADS, 1945. This is the intersection of Santa Monica and Wilshire Boulevards looking west to the Los Angeles Country Club. The center triangle of the Beverly Hills Nursery is the later site of the Beverly Hilton Hotel (1955). To the upper left is the entry gate for 20th Century Fox Studios and a portion of the back lot, which later became Century City.

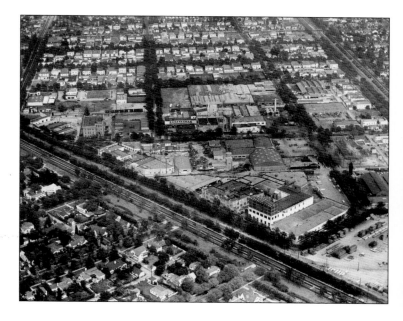

BEVERLY HILLS INDUSTRIAL TRIANGLE, 1946. From Santa Monica Boulevard at the bottom to Burton Way at the right of the photograph, the industrial triangle consisted of the Sun Lumber Company, the Continental Bakery Factory, Mutual Building Materials Company, Ice factory, Litton Industries, and the Beverly Hills Tennis Club, among others.

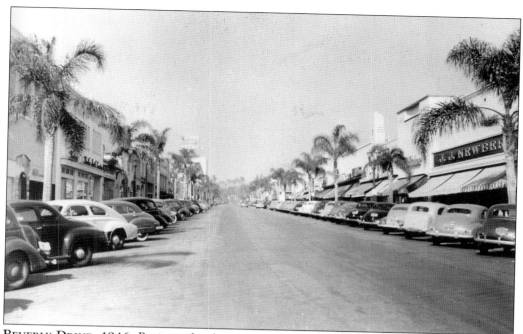

BEVERLY DRIVE, 1946. Business development in Beverly Hills during World War II was in a state of suspension. As soon as the war was over, new investments helped Beverly Hills into an economic boom resulting in new businesses opening and old ones rejuvenating. By 1946, business on Beverly Drive was growing, evidenced by no available parking spaces in this photograph.

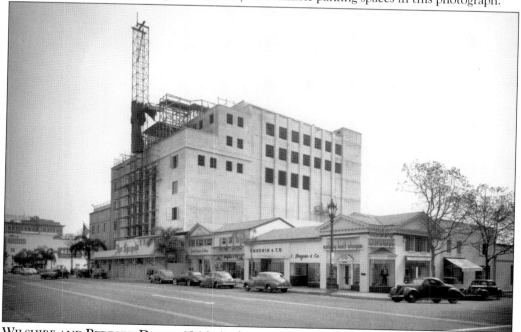

WILSHIRE AND BEDFORD DRIVE, 1946. At this time, Saks Fifth Avenue was under construction. Note the small store of I. Magnin and Company, established in Beverly Hills in the late 1930s. On the southeast corner was the Hobby Knit Shops store.

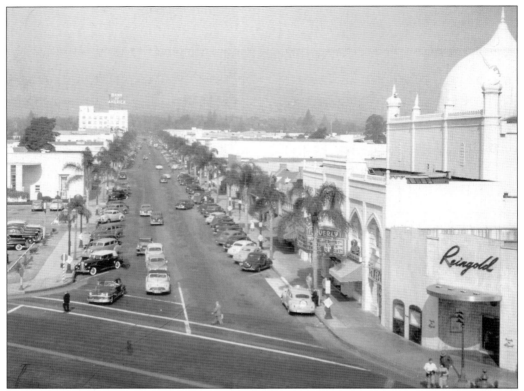

BEVERLY DRIVE AT WILSHIRE, 1947. This scene of Beverly Drive was taken at the beginning of the postwar Beverly Hills economic boom. The Beverly Theater, right, was showing RKO's *The Long Night*, starring Henry Fonda, along with two other features on one billing. At the right is Reingold Jewelers, and up the street to the left is the Adrian Couture showroom.

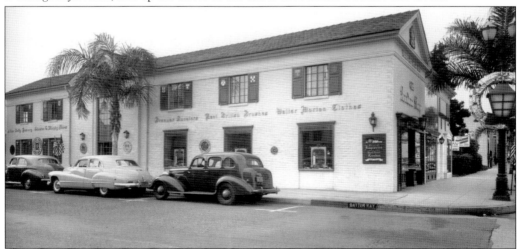

DAYTON WAY AND RODEO DRIVE, 1947. Located on the northwest corner was the London Shop of Beverly Hills. Many of the specialty stores in Beverly Hills were established in the late 1930s as a method of surviving the Great Depression. By 1940, Beverly Hills had an international reputation for shops that specialized in quality merchandise or special services offered to the public.

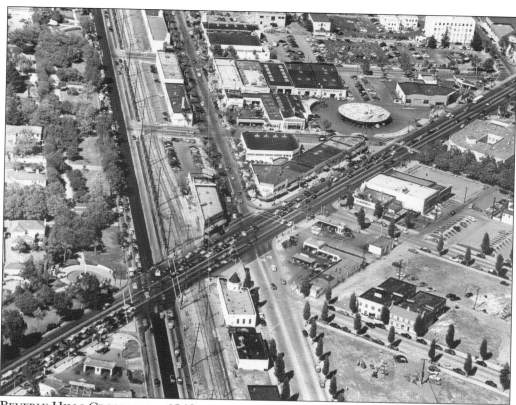

BEVERLY HILLS CROSSROADS, 1948. In the early 1920s, the crossroads of Wilshire and Santa Monica Boulevards were always a problem for drivers due to the lack of any streetlights. Even after a complicated streetlight system was installed in the late 1920s, the crossroads continued to cause traffic problems well into the 1990s. The round-roofed building at the top right of the photograph is Simon's Drive-In, a popular eatery in Beverly Hills at the time.

CALIFORNIA BANK BUILDING, 1948. The California Bank has always been the most prominent Beverly Hills landmark in the city. Located on the northeast corner of Beverly Drive and Wilshire Boulevard, the building was once an investment property of MGM Studio mogul Louis B. Mayer and later became known as the Sterling Building in the 1990s.

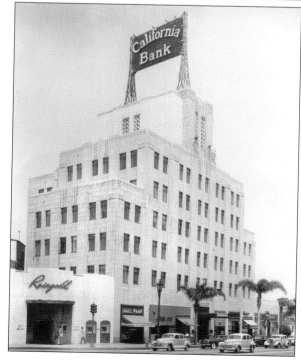

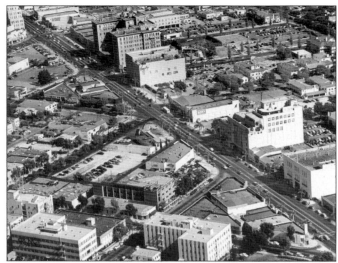

WILSHIRE BOULEVARD CORRIDOR, 1948. Department store row in Beverly Hills was between Beverly Drive on the east side and Spalding Drive on the west. At this time, some of the major department stores were I. Magnin and Company, Saks Fifth Avenue, Kerr's Sporting Goods, and J. J. Haggarty's.

BEVERLY HILTON HOTEL CONSTRUCTION, 1954. Looking east at Wilshire and Santa Monica Boulevards, this photograph shows the Beverly Hilton under construction in July. In 1950, Conrad Hilton filed for an application to build a $17 million hotel on the site of the Beverly Hills Nursery. The hotel opened in August 1955, making it the third major hotel in Beverly Hills. Adjacent to the hotel construction site is the Robinson's Beverly department store that opened on February 11, 1952.

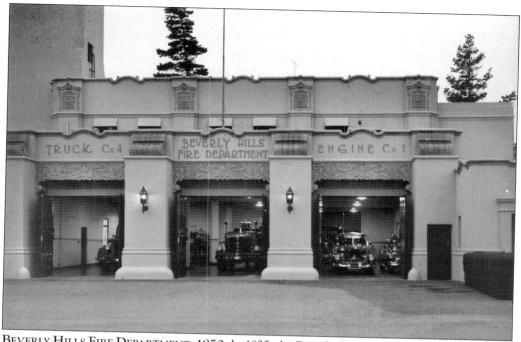

BEVERLY HILLS FIRE DEPARTMENT, 1950. In 1925, the Beverly Hills Fire Department (originally a unit of the Beverly Hills Police) came into its own entity as a separate organization. When the new city hall was built in 1932, a new and separate fire station building was added adjacent to the civic center.

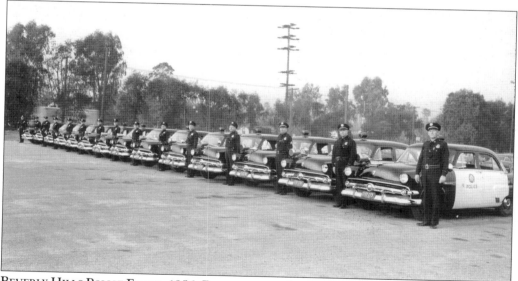

BEVERLY HILLS POLICE FORCE, 1956. Fourteen new police cars are pictured with officers standing at attention. The Beverly Hills Police Department was originally formed to protect the city's citizens from crimes that were either committed within the city limits or transient criminals passing through. Motor officers and patrol cars are the backbone of policing Beverly Hills from the "hills to the flats." As early as the 1920s, a sign could be found at the city limits saying, "Burglars and Robbers—Stay Out!"

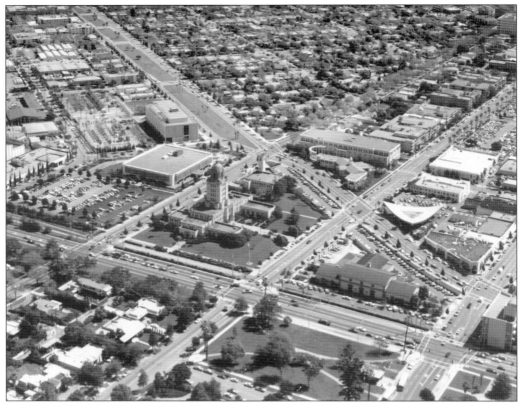

BEVERLY HILLS CIVIC CENTER, 1971. This photograph looks east toward downtown Los Angeles along Burton Way. Adjacent to the original Beverly Hills City Hall on Crescent Drive are the Beverly Hills Public Library, which opened on October 10, 1965, and on Burton Way the Beverly Hills Municipal Court at Alpine, which opened in 1970.

HEEGARD BUILDING, 1948. Located at 9515 South Santa Monica Boulevard near Canon Drive, the Heegard Building's tenants in the 1940s included dentists, lawyers, a barbershop, a shop selling typewriters and sewing machines, real estate office, a yarn store, a rug shop, and a women's clothing store.

Four

BEVERLY HILLS IN THE 1950S
1950–1959

With the announcement that Conrad Hilton would build a new hotel in Beverly Hills, postwar growth continued at a phenomenal pace. Business continued to break merchandising and services records. The city was again renewing itself with the construction of new and modern buildings.

Some famous historic estates in the area were either remodeled or demolished and subdivided. The Marion Davies estate on Lexington Drive was subdivided, leaving the main house intact, but its grounds were developed into lots. The E. L. Doheny estate was sold and subdivided into a development named Trousdale Estates between 1955 and 1957. By the end of the 1950s, other historic estates were in question. The Cord, Bayerknoll, Schuyler, Marco Hellman, and Burton Green estates were either sold, subdivided, or demolished altogether.

Large eastern businesses opened offices and stores in Beverly Hills. Movie star residents continued to congregate at the famed Beverly Hills Brown Derby but were seen patronizing other businesses. In late 1950, the Beverly Hills YMCA opened a new building on South Santa Monica Boulevard, continuing a long tradition in the city. Gloria Swanson officiated at a ceremony marking completion of the installation of almost 900 new street signs. The original Sunset Park, given to the city of Beverly Hills by the Anderson family of the Beverly Hills Hotel, was renamed in 1952 as Will Rogers Memorial Park. Also in 1952, J. W. Robinson's opened its showplace store on February 11. Frank Lloyd Wright opened one of the last buildings he designed on Rodeo Drive in 1953. In 1954, the Beth Jacob Congregation, an Orthodox synagogue, opened its new temple on Olympic Boulevard. New restaurants opened in Beverly Hills during the 1950s, including The Luau, Lawry's Prime Rib, Melody Lane, Dolores' Drive In, Blum's, Trader Vic's, and Romanoff's, which moved to a larger location south of Wilshire Boulevard on Rodeo Drive in 1951. Businesses included Carroll and Company clothiers, Elizabeth Arden, Don Loper Boutique, Uncle Bernie's Toy Menagerie, Hunter's Bookstore, and others.

In 1957, Beverly High School marked its 30th anniversary. New residents, more construction, and increased traffic occurred. During the 1950s, the police acquired new radio cars and other equipment. The Sunset Boulevard Bridle Path's use changed from horses to bicycles and, by the end of the 1950s, was removed altogether. The railroad and Pacific Electric trolley cars that were a part of Beverly Hills life began to disappear by 1965.

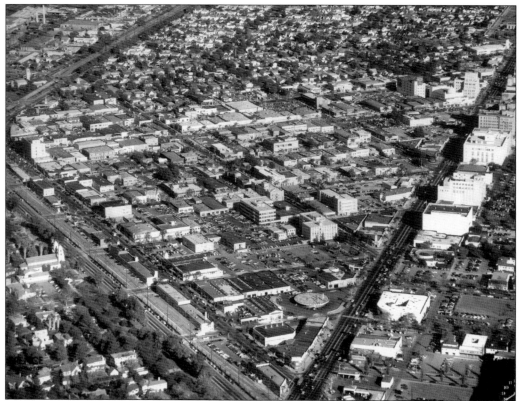

THE BEVERLY HILLS BUSINESS TRIANGLE, 1950. Looking east from the intersection of Santa Monica and Wilshire Boulevards, the city of Beverly Hills was undergoing a continued economic boom with new residents and businesses entering the city throughout the 1950s. At right is the Wilshire department store corridor and at top left is Burton Way.

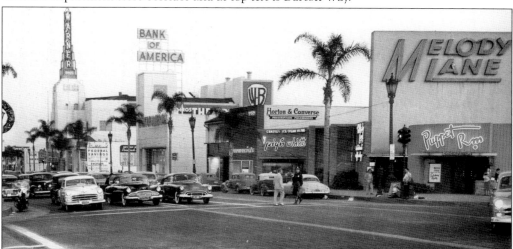

BEVERLY DRIVE AND WILSHIRE BOULEVARD, 1950. Melody Lane and its Puppet Room were located on the southeast corner; next door was a branch of the Pig'n Whistle restaurant. By the 1960s, Melody Lane was replaced by Blum's restaurant and its famous fountain deserts.

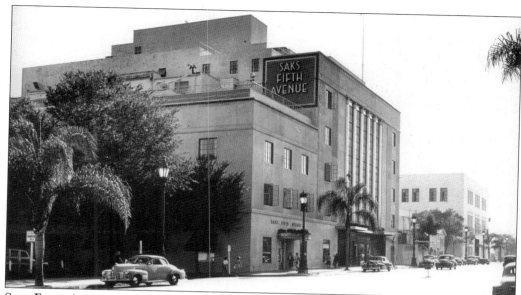

SAKS FIFTH AVENUE, 1950. When Saks Fifth Avenue came to Beverly Hills in 1938 the advertising touted, "New York comes to Beverly Hills." Further down Wilshire, a block away, is I. Magnin and Company. In 1995, Saks opened a new annex called Saks West, adjacent to the original store. The cosmetics department acted as a background for the 1939 film *The Women*. In the 1950s, Marilyn Monroe was a frequent shopper with a penchant for clothes by Italian designer Pucci.

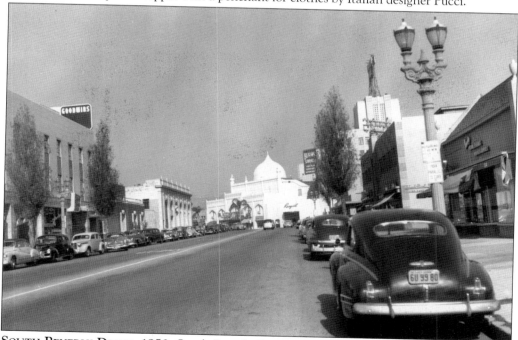

SOUTH BEVERLY DRIVE, 1950. South Beverly Drive was developed into its present residential and commercial district first in the late 1930s and again in the late 1940s. Looking north to the Beverly Theater at Wilshire Boulevard, the iconic theater building, with its East Indian onion dome, marked the heart of the downtown business district of Beverly Hills.

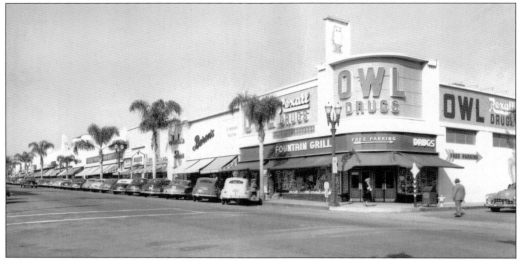

BEVERLY DRIVE AND DAYTON WAY, 1950. The Owl Drug Store, located on the northeast corner at 300 North Beverly Drive, was a landmark building in Beverly Hills for almost 40 years. At this time, the Beverly Drive business district was the prime shopping street in the city. Rodeo Drive became the dominant shopping street in the 1980s.

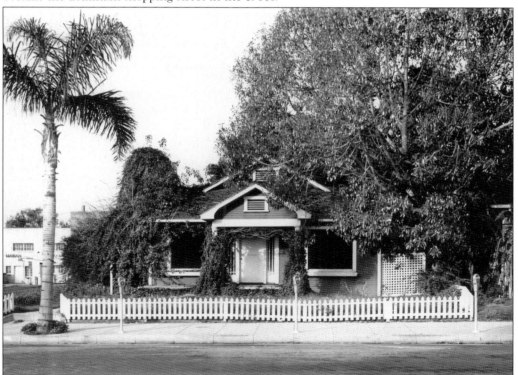

RODEO DRIVE AND BRIGHTON WAY, 1951. In the 1950s, Rodeo Drive was part business and part small bungalow houses, survivors from the 1920s when south Rodeo Drive was a residential district. Some of the bungalows became businesses, the most prominent being Mama Weiss' Csarda Hungarian Restaurant from the 1930s to the 1950s.

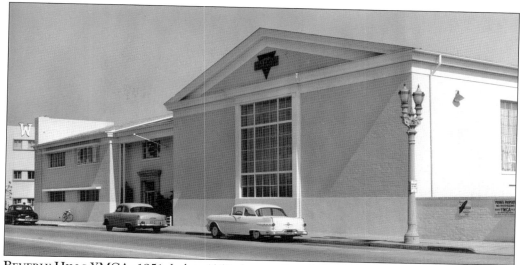

BEVERLY HILLS YMCA, 1951. In late 1950, the new Beverly Hills YMCA building was opened as "a boost for the youngsters of the community." It was constructed at 9930 Santa Monica Boulevard near the western boundary of Beverly Hills. The building was constructed at a cost of $250,000 and became a social center for Beverly Hills residents.

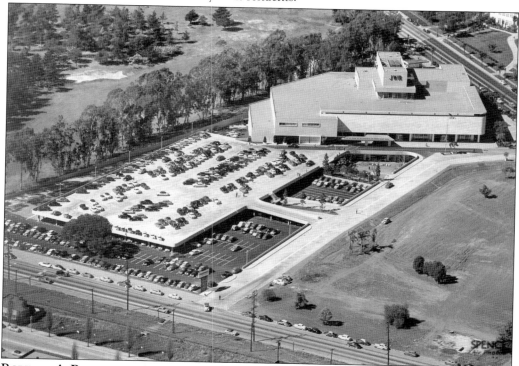

ROBINSON'S BEVERLY, 1952. J. W. Robinson's was to be the showplace of the Los Angeles area when it opened on February 11, 1952. It became the meeting place for residents and celebrities from the 1950s to the 1970s. One could see famous movie, radio, music, and entertainment personalities shopping in the store. Over the years, the store acted as a background for motion pictures and television shows, publicizing the store and Beverly Hills around the world.

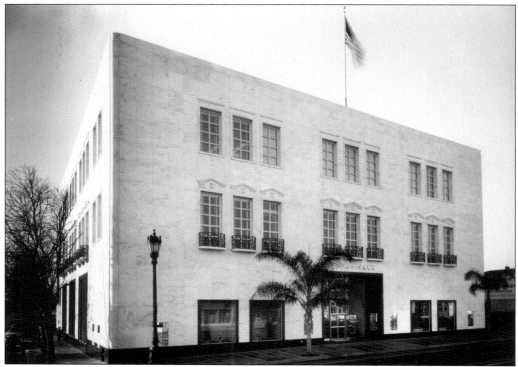

I. Magnin and Company, 1952. Located at 9634 Wilshire Boulevard, the five-floor French-style building was erected in 1941 by the Magnin family to cater to the most fashionable clientele of Beverly Hills. In December 1994, Saks Fifth Avenue acquired the Magnin building with the intent of remodeling it into a new men's store.

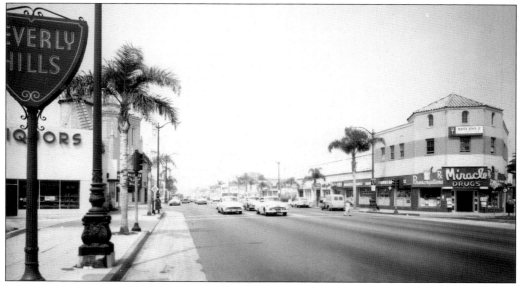

Wilshire Boulevard and San Vicente, 1953. The eastern border of Beverly Hills during the 1950s was a bustling business district. A Van de Kamp windmill bakery building (partially obscured by the Beverly Hills shield sign) had been a Beverly Hills landmark since the 1930s.

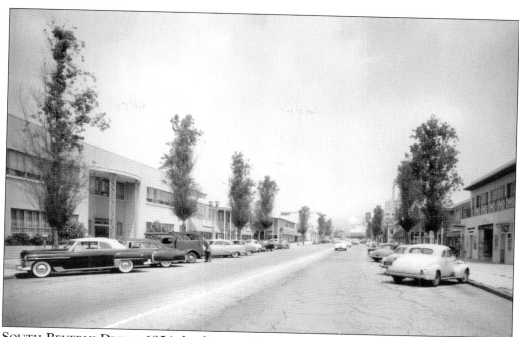

SOUTH BEVERLY DRIVE, 1954. Looking north toward the Corinne Griffith "Four Corners" buildings at Charleville and Beverly Drive, the most prominent building in this photograph (left) is the Allen Parks Building at 211 South Beverly Drive.

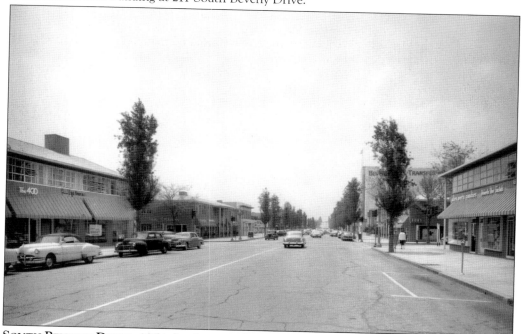

SOUTH BEVERLY DRIVE, 1954. Looking south on Beverly Drive to Charleville, this intersection was known for many years as the "Four Corners," owned by silent film star Corinne Griffith. Four Corners was famous in Beverly Hills for having such landmarks as Will Wrights Ice Cream Parlor (on the southeast corner) and Allen Wertz Candies Company (on the northwest corner).

CORINNE GRIFFITH CORNER, BUILDING NO. 4, 1954. At Beverly Drive and Charleville, the Allen Wertz Candies Company occupied the northwest corner and has been a Beverly Hills landmark since the 1950s. The building in this photograph was named Corinne Griffith Building No. 4, which was a part of the Four Corners intersection.

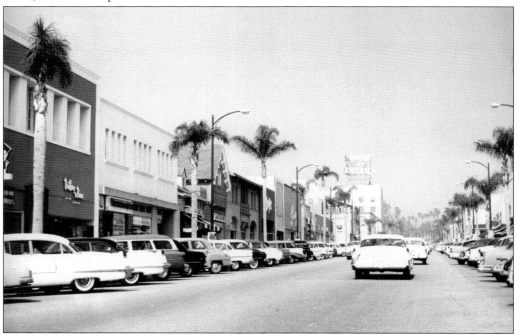

BEVERLY DRIVE, 1956. North on Beverly Drive to Santa Monica Boulevard, in the 300 block showing the Bank of America building on the southwest corner of Santa Monica and Beverly Drive, is the present site of the Museum of Broadcasting. To the left is the Berlitz School of Languages building at 321 North Beverly Drive.

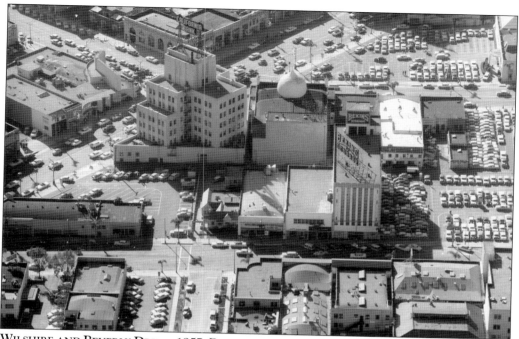

WILSHIRE AND BEVERLY DRIVE, 1957. Downtown Beverly Hills during the 1950s has the Beverly Theater with its onion dome, California Bank Building, Bekins Storage building on Canon Drive, and the Canon Theater, which was presenting the play *and God Created Woman* at the time. Below is Clifton Drive intersecting Canon Drive.

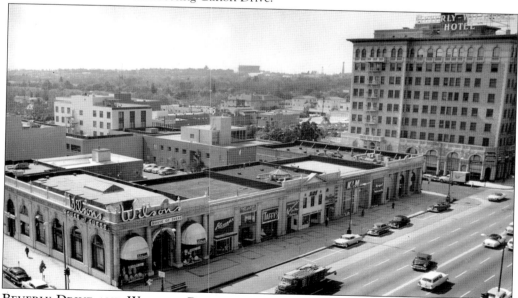

BEVERLY DRIVE AND WILSHIRE BOULEVARD, 1957. The building on the southwest corner housed a bank in the 1930s and the Myron Selznick Agency in the 1940s. Wilson's House of Suede moved in the 1970s to the corner building with the pointed roof at Santa Monica and Wilshire Boulevard. Near the end of the 1950s, an eight-story Union Bank and Trust building was planned for the entire block.

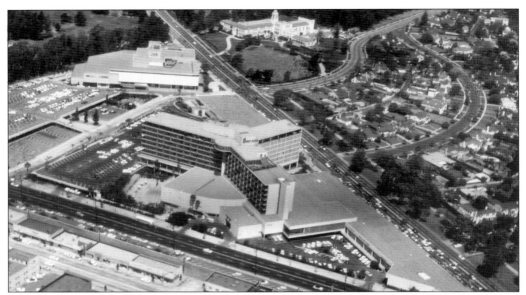

BEVERLY HILTON HOTEL, 1958. The Hilton was only three years old when this photograph was taken. Located on the west boundary of Beverly Hills, the Hilton and the J. W. Robinson's store adjacent to the hotel created an entirely new business center at the close of the 1950s. The Spanish-styled structure at the top center is the El Rodeo School on Whittier Drive, with the Los Angeles Country Club golf course behind.

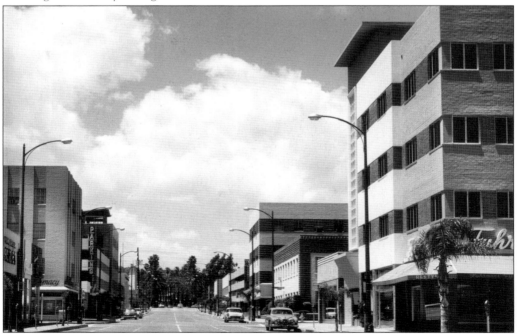

BEDFORD DRIVE, 1958. Looking north to Brighton Way in the 300 block of Bedford Drive, one could find several medical buildings interspersed with businesses such as Fuhrman's Furs, Maurice and Son Custom Tailors, and Hamburger Hamlet restaurant, as well as pharmacies and several boutiques.

ROBINSON'S BEVERLY STORE, 1959. J. W. Robinson's Beverly Hills showplace, which opened in 1952, was the first major development on the western border of Beverly Hills. Located adjacent to the Los Angeles Country Club golf course, the store became a social center for the nearby residents. Its landmark architectural design retained its elegant styling well into the end of the century. In 2005, the store closed and a condominium project was planned for the site.

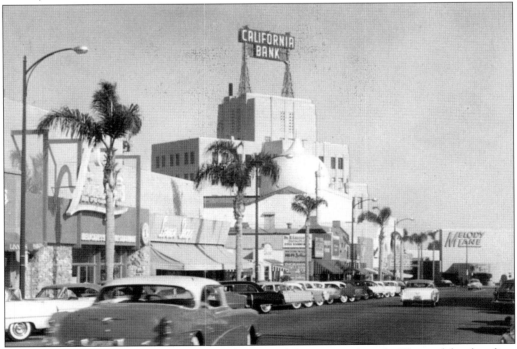

BEVERLY DRIVE, 1956. The caption on the rear of this postcard reads, "Beautiful palms line Beverly Drive, famous for its exclusive shops, in the heart of this celebrated residential community surrounded by the City of Los Angeles." At this time, the most popular businesses on the east side of the street were Linney's Delicatessen and Melody Lane at the end of the street.

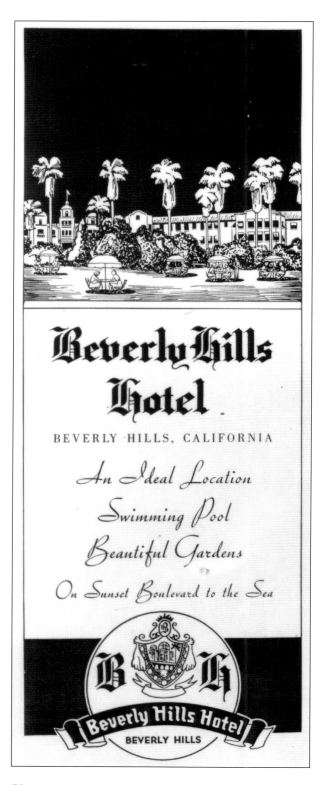

BEVERLY HILLS HOTEL ADVERTISEMENT, 1938. By the end of the 1930s, the Beverly Hills Hotel was open again for business, having been closed for renovations into a newer design yet keeping its historical character.

Five

THE BEVERLY HILLS HOTEL
1930–2005

Since the Beverly Hills Hotel opened in 1912, it has been the town's center of glamour, civic events, recreation, and commercial activities. Built and opened by Margaret J. Anderson, the hotel thrived as the heart of Beverly Hills community life. In 1928, Mrs. Anderson sold the hotel, which closed during the Depression. In 1934, the Bank of America, as trustee, reopened the hotel after its first renovation and redecoration. The original children's dining room (which had been remodeled into a restaurant-bar named Le Jardin) was transformed into a bar called the Polo Lounge as a memorial for patrons Will Rogers and his polo playing friends, including Darryl F. Zanuck, Jack Holt, Frank Borzage, and Hal Roach.

In 1936, Hernando Courtright, the bank's vice president, was appointed to oversee the hotel's operation. In 1937, Garson Kanin wrote, "The hotel was as romantic as ever . . . a fire was burning in the lobby fireplace, a tradition, said to be based on the custom of Spanish settlers' inns." Using the talents of Paul Lazlo, Jack Lucareni, Don Loper, and Harriet Shellenberger, Courtright redecorated again in 1937 with different designs in each room and lighting fixtures by the Leo Dorner and Company. Loper designed the wallpaper's distinctive pink and green banana leaves. The swimming pool was also installed in 1937. Charles Chaplin reserved the Polo Lounge's table No.1 when he was in attendance. In 1939, the hotel hosted parties and events featuring Marlene Dietrich, Katharine Hepburn, Cary Grant, and David O. Selznick.

By 1941, Courtright organized investors to purchase the hotel. In 1942, Howard Hughes took up long-term residency, keeping ongoing reservations for over 30 years. By 1943, investors included film stars Loretta Young, Irene Dunne, and Harry Warner of Warner Brothers. Courtright hired architect Paul Williams in 1943 and interior designers Paul Laszlo and John Luccareni to redesign the lobby. It and the sunroom opened in December 1944. Renovation and redecoration were completed in 1947. The Crystal and Lanai Rooms were opened along with other rooms for private parties. The Crescent Wing, a major addition designed by Williams, was completed in 1949. During the making of 20th Century Fox's *Let's Make Love* in 1960, Marilyn Monroe stayed at the hotel. The Persian Room opened in 1966. In 1987, the hotel celebrated its 75th anniversary. At the end of 1992, the hotel would close for a major renovation and would reopen on June 4, 1995.

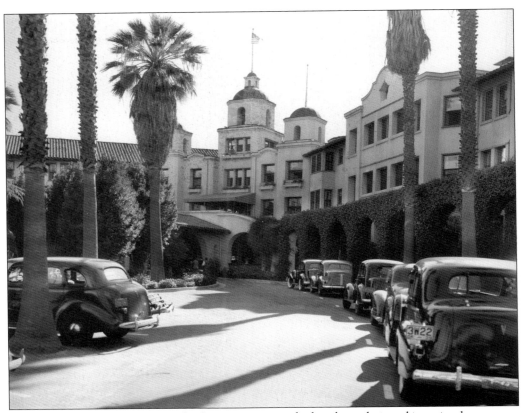

BEVERLY HILLS HOTEL, 1939. The front entrance to the hotel was designed in a circular pattern, with cars entering from Crescent Drive and exiting on Hartford Way. The classic Spanish Colonial architecture was a distinct statement addressing the Spanish California heritage of the area, which was once a Spanish rancho in the 19th century.

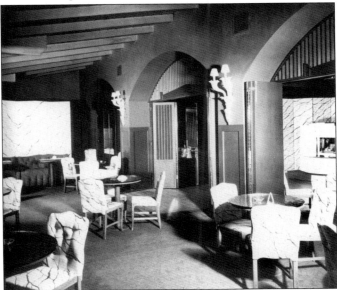

BEVERLY HILLS HOTEL LOUNGE, 1934. After the hotel opened, a couple of years at the beginning of the Depression, the children's dining room was remodeled into a bar and lounge. By 1934, Will Rogers was bringing his polo-playing friends to the new bar. In 1937, the new owner of the hotel, Hernando Courtright, decided to change the decor and name of the bar to the Polo Lounge partly in honor of Will Rogers, who died in 1935.

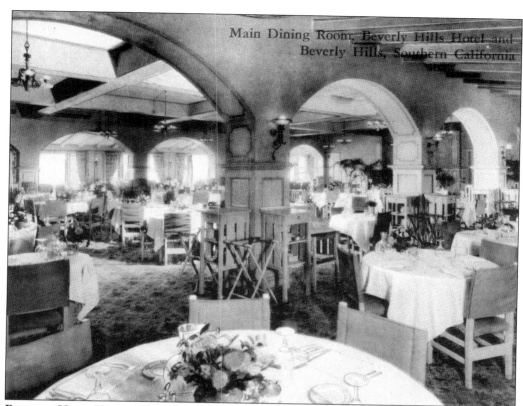

BEVERLY HILLS HOTEL MAIN DINING ROOM, 1929. This view of the dining room shows the Spanish-styled rooms with their signature arches. The hotel was originally a resort hotel in the early 1910s. With the coming of the 1930s, the hotel was modernized and remodeled, updating the interior into more of a luxury hotel to attract more international guests.

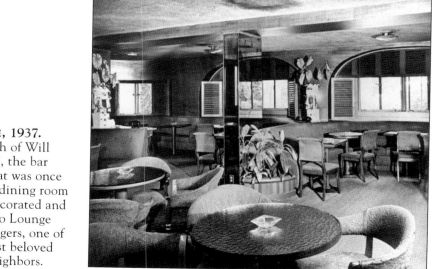

POLO LOUNGE, 1937. After the death of Will Rogers in 1935, the bar and lounge that was once the childrens' dining room was again redecorated and named the Polo Lounge in honor of Rogers, one of the hotel's most beloved visitors and neighbors.

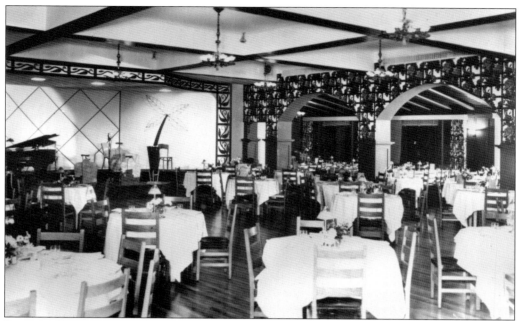

BEVERLY HILLS HOTEL MAIN DINING ROOM, 1935. The main dining room was remodeled in 1934, bringing its decor up-to-date in a general redecorating of the entire hotel. The original Spanish-style arches were not altered, just decorated along with the ceiling.

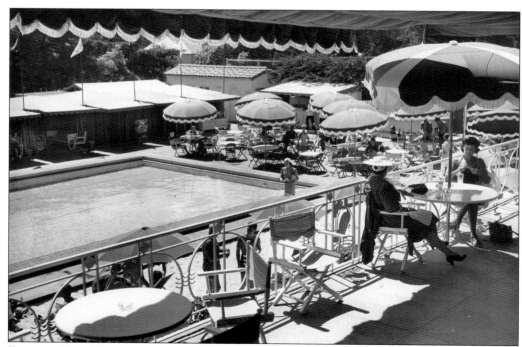

BEVERLY HILLS HOTEL POOL AREA, 1938. This is a view of the swimming pool area from the hotel's outer terrace. The hotel pool was built in 1935 during the overall remodeling of the hotel and its grounds. The pool area included a sandy beach and cabana section.

BEVERLY HILLS HOTEL NOTE LETTERHEAD, 1938. Actress Helen Hayes wrote this note to Hobart Bosworth, famed stage and screen actor of the early 20th century, while she was starring on the Los Angeles stage.

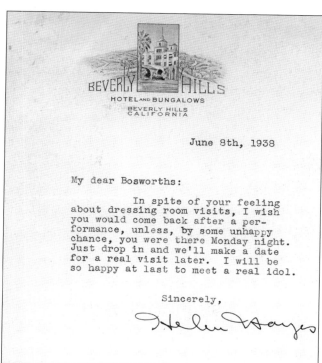

BEVERLY HILLS
HOTEL AND BUNGALOWS
BEVERLY HILLS
CALIFORNIA

June 8th, 1938

My dear Bosworths:

In spite of your feeling about dressing room visits, I wish you would come back after a performance, unless, by some unhappy chance, you were there Monday night. Just drop in and we'll make a date for a real visit later. I will be so happy at last to meet a real idol.

Sincerely,

Helen Hayes

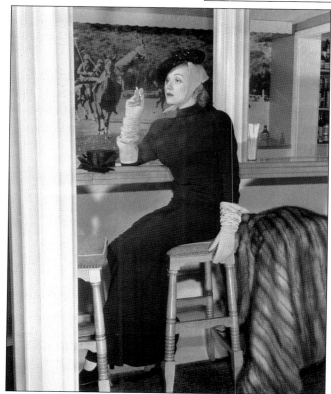

POLO LOUNGE, 1937. Film actress Marlene Dietrich poses at the bar in the Polo Lounge. The newly decorated bar and lounge was named in honor of Will Rogers and his polo-playing teams that were regular patrons in the 1920s and 1930s.

BEVERLY HILLS HOTEL BUNGALOWS, 1940. One of the more unusual amenities the hotel offered to its guests was the option of staying in an exclusive and private bungalow. Before Gloria Swanson purchased the King Gillette estate across the street in 1921, she considered one of the bungalows her home. In later years, Howard Hughes leased his favorite bungalow on a yearly basis even though he was not a regular guest. The bungalows were added to the original plan due to the families that used to come to the hotel and use the bungalows as private houses.

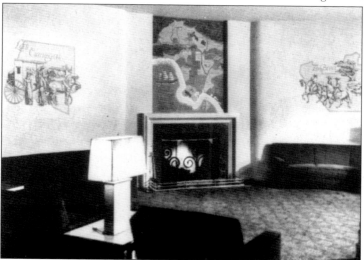

HOTEL LOBBY FIREPLACE, 1945. The Millard Sheets mural above the lobby fireplace shows a colorful map of early Southern California. The hotel stood on the Rancho Rodeo de las Agues (the gathering of the waters), which refers to the artesian wells and streams that run out of the foothills. The hotel lobby was one of the first public areas of the hotel that was remodeled in the 1944 renovation.

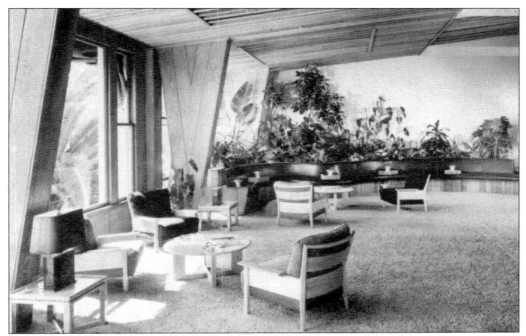

LOBBY SUNROOM, 1945. The sunroom, or lobby lounge, was designed by John F. Luccareni, who was noted for his skill in combining colors subtly and harmoniously. The sunroom remodeling was a part of the overall hotel renovation begun in 1937 and completed in 1949.

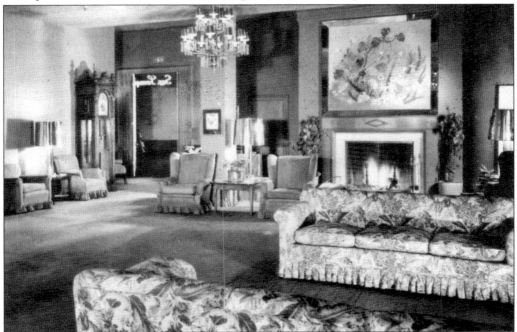

SUNROOM LOUNGE AND FIREPLACE, 1945. This corner of the sunroom lounge, with the mural of flowers over the fireplace painted by sisters Jenne and Ethel Magafan, was designed as a private residence living room.

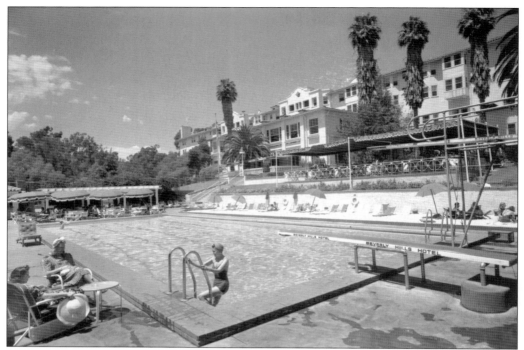

SWIMMING POOL AND CABANA, 1938. The new swimming pool area was constructed in 1937 at the beginning of a long-term overall renovation plan that ended in 1949. The swimming pool became a famous location for entertainment personalities to be seen and publicized around the world.

BEVERLY HILLS HOTEL AND BUNGALOWS POSTCARD, 1968. The Paul Williams 1949 addition to the hotel was named the Crescent Wing due to its location on Crescent Drive. The modern wing was used as a marketing tool to publicize the hotel.

BEVERLY HILLS HOTEL, 1950. The hotel is seen from Sunset Park across the street. The new Paul Williams wing of the hotel dominated the old view that was known for its Mission-style architecture. The script sign on the new wing became an icon of the hotel.

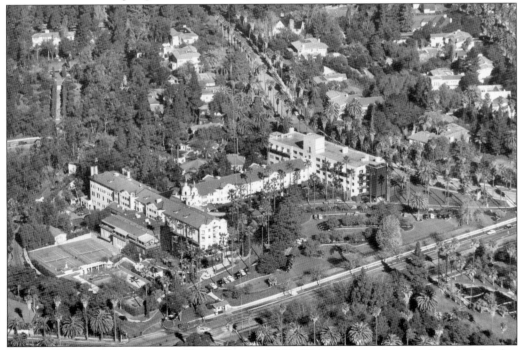

AERIAL VIEW OF THE BEVERLY HILLS HOTEL, 1949. This photograph was taken shortly after the dedication of the new Crescent Wing, designed by architect Paul Williams. The new wing was the last major renovation that was begun in 1937.

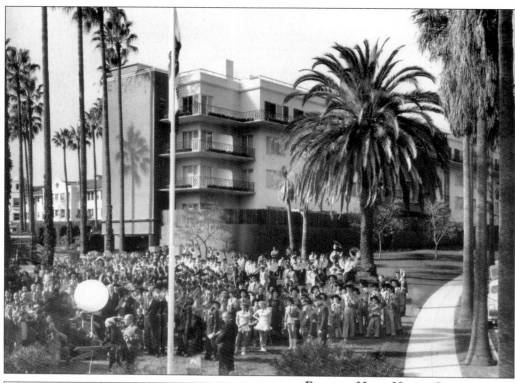

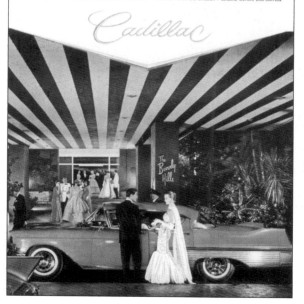

BEVERLY HILLS HOTEL CRESCENT WING DEDICATION, 1949. On April 19, the state flag was raised at the opening dedication as hotel owner-manager Hernando Courtright released a balloon carrying the symbolic key to the new hotel wing. In December, a parade of film notables rode on horseback from city hall to the hotel for a Crescent Wing opening party with film star William Boyd (Hopalong Cassidy) as the master of ceremonies.

CADILLAC ADVERTISEMENT, 1957. The staging of this advertisement was at the more modern porte cochere green-striped entrance to the Beverly Hills Hotel. The color of the Cadillac in the photograph is pink, the same as the hotel's color scheme of green, white, and pink. On January 23, 1954, it was announced that Ben L. Silberstein, Detroit investor, acquired a substantial stock position in the Beverly Hills Hotel Corporation, the first major stock purchase since the 1930s.

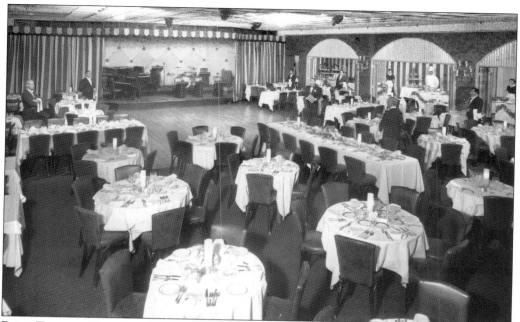

PALM TERRACE ROOM, 1950. According to a hotel brochure, this was "the large commodious salle-a-manger, the one great room that maintains our fine old Spanish tradition." The room was redesigned in 1948 as a dining and dancing ballroom, originally the arched main dining room during the 1920s and 1930s.

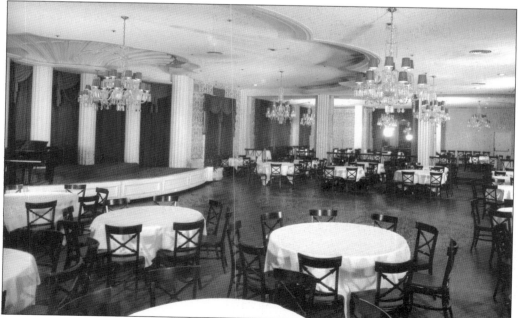

CRYSTAL ROOM, 1951. This ballroom was remodeled in 1947 into an elegant and formal room with a stage for dining and dancing parties. It was in this room that Prince and Princess Rainier of Monaco, Queen Juliana of Netherlands, and President Sukarno of Indonesia were guests in the early 1950s.

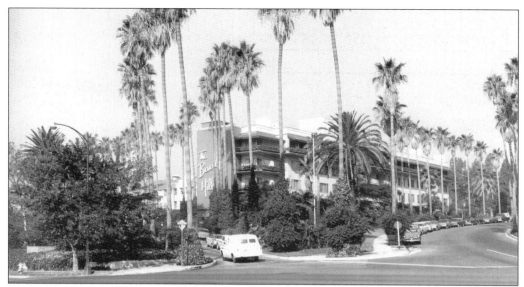

CRESCENT DRIVE ENTRANCE TO THE BEVERLY HILLS HOTEL, 1960. The hotel was going through major changes again at the end of the 1950s, with new investors and renovation additions. It was at this time that Burton Slatkin was named director and vice president of the hotel. In 1960, during the making of the film *Let's Make Love* for 20th Century Fox, the principal stars of the film stayed at the hotel. Marilyn Monroe and Arthur Miller made bungalow 10 their home while she was working on the film.

POLO PATIO, 1974. The Polo Lounge opened an outdoor patio dining area in 1961. Named the Polo Patio, it became one of the most popular amenities at the Beverly Hills Hotel and remains so today. During the 1960s, one could find such notables as Marilyn Monroe, Pres. John F. Kennedy, Dean Martin, Carol Burnett, Richard Conte, Lord Snowdon and Princess Margaret of Great Britain, Robert Mitchum, Elizabeth Taylor, Eddie Fisher, Richard Burton, Zsa Zsa Gabor, Kim Novak, Raquel Welch, Gregory Peck, Lucille Ball, and many others eating on the Polo Patio.

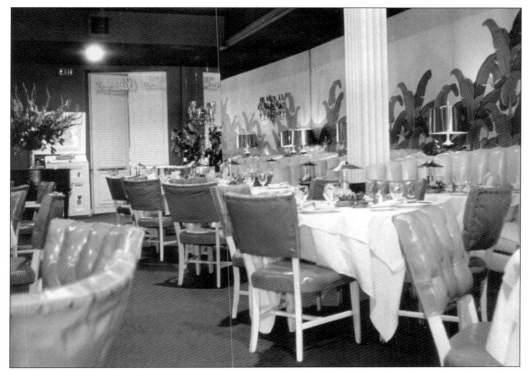

LANAI ROOM, 1957. Opened in 1947 and later renamed the Coterie Room in 1986, this was the main dining room of the hotel. Decorated with Don Loper green banana leaf wallpaper, which later became the signature decoration of the Beverly Hills Hotel, the Lanai Room became world famous hosting such celebrities as Elizabeth Taylor, Danny Kaye, Dorothy Lamour, Katharine Hepburn, Al Jolson, Paulette Goddard, Hedy Lamarr, writer Maxwell Anderson, and Ingrid Bergman.

ELEVATOR HALLWAY, 1957. The signature Don Loper green banana leaf wallpaper motif was a design factor in the 1947 renovation of the hotel. Each leaf was cut out and individually pasted to the walls in the entire hotel. Along with the new color scheme of green, white, and pink, the hotel was beginning a new era as the premiere hotel of Beverly Hills.

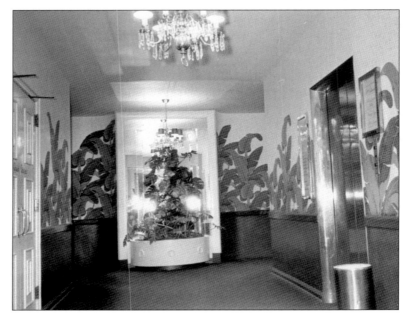

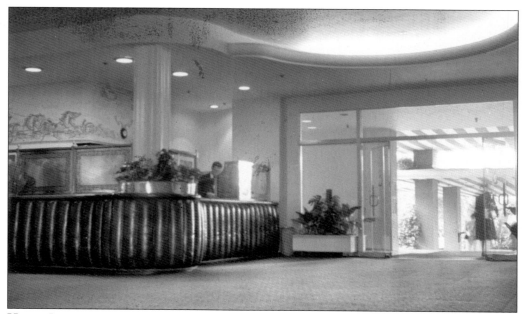

HOTEL LOBBY DESK, 1957. This view of the front desk shows the Millard Sheets murals above and behind the padded desk area. The entire lobby, remodeled in 1945, shows the fluorescent lighting hidden in the ceiling giving an indirect and cool lighting effect.

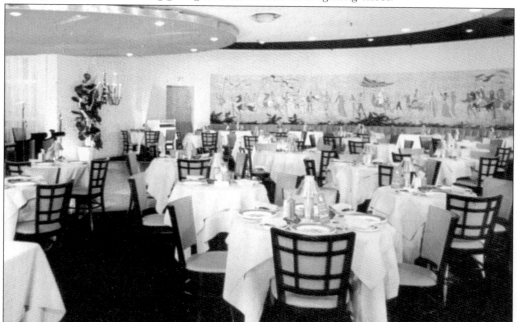

PERSIAN ROOM, 1966. Created in 1964 during the general renovation of the hotel amenities, the Persian Room was advertised as "colorful, festive and smart for dinner dancing." On the back of this postcard, hotel director Hernando Courtright wrote to a Beverly Hills resident, "Come and see us . . . It's more fun and more for your money too when you entertain at the Beverly Hills Hotel. Your friends and family will enjoy our hospitality here."

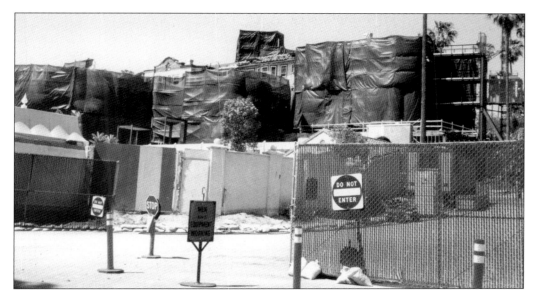

BEVERLY HILLS HOTEL COMPLETE RENOVATION, 1994. Almost completely covered in green tarps during the two-year renovation, the Beverly Hills Hotel would begin a new era when it opened on June 4, 1995. This view from the Hartford Way driveway exit shows the monumental work that was undertaken beginning in 1993.

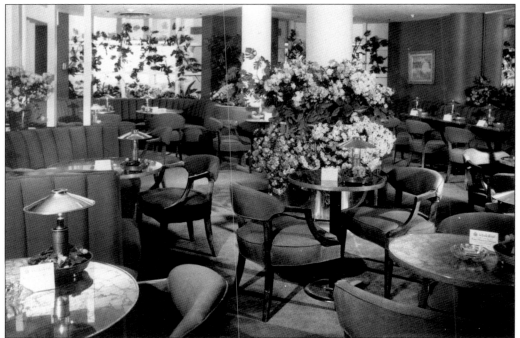

POLO LOUNGE, 1995. As reported in the *Los Angeles Times* magazine supplement of May 21, 1995, excerpts of an article said, "The Pink Palace . . . what becomes of a legend most? For the Beverly Hills Hotel, a pricey face-lift, lots of banana leaves and of course the Polo Lounge. The legendary Polo Lounge, host to many of the world's most powerful, talented and beautiful people, has been meticulously restored."

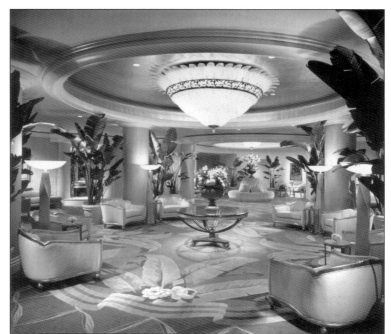

HOTEL LOBBY, 1995. The lobby was changed into boudoir shades of apricot with the signature green banana leaf motif on the walls and carpeting, and its curvy ceiling highlights are gilt gold giving the room a warm but contemporary feeling.

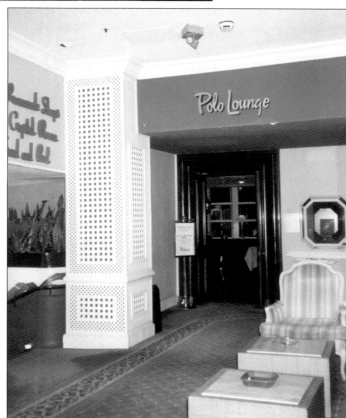

ENTRANCE TO THE POLO LOUNGE, 1992. This photograph was taken on December 30, 1992, just before the hotel closed for its two-year renovation. The original wooden doorway entrance was installed when the Polo Lounge was born in 1937.

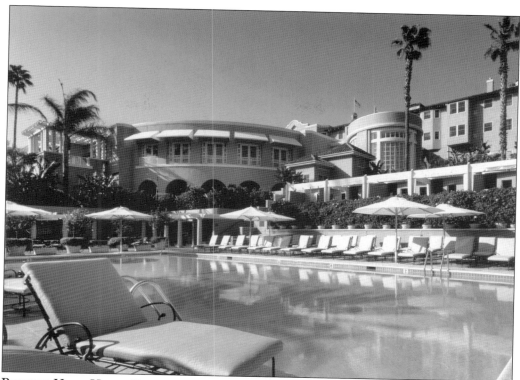

BEVERLY HILLS HOTEL POST RENOVATION, 1996. The newly renovated swimming pool area is backed by the west wing of the hotel. The west wing included the grand ballroom and staircase with views of Beverly Hills. The repainting of the hotel took about 1,600 gallons of "Beverly Hills Pink" that was matched to the original colors. The swimming pool area is designed with a heated whirlpool spa and a Spanish fountain.

CRESCENT WING, 1997. In the Beverly Hills Chamber of Commerce's 1997 *Guide to Beverly Hills*, it was said, "The legendary Beverly Hills Hotel is back in all its grandeur! After a two-and-one-half-year restoration, the Pink Palace looks ravishing and its trademark Polo Lounge and Pool sparkle like new and continue to draw the worlds most powerful and famous. The hotel's grounds cover 12 acres of gardens, making it the only true urban resort in Beverly Hills."

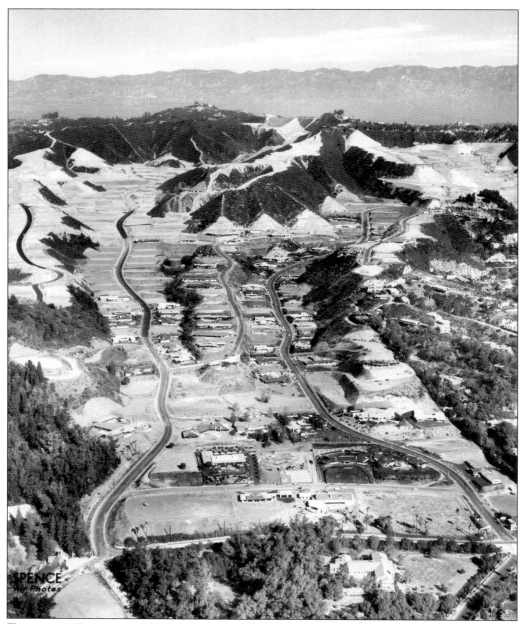

TROUSDALE ESTATES, 1958. By the end of the 1950s, the Trousdale Estates development was the largest in the history of Beverly Hills. Formerly the Doheny Ranch, the new tract of lots overlooking Beverly Hills already attracted some of the town's most famous residents: Groucho Marx, Richard M. Nixon, Cornel Wilde, and Dinah Shore. The historic Cord Estate can be seen in the foreground of this photograph on Doheny Road.

Six

ESTATES IN
BEVERLY HILLS
1930–1990

A 1921 Beverly Hills real estate brochure proclaimed the Rodeo Land and Water Company's motto as an "exclusive residence district in the foothills between Los Angeles and the Sea." The first house was built in 1907 on Crescent Drive just north of Santa Monica Boulevard by Henry C. Clark, the town's first real estate agent. In 1911, Mr. and Mrs. Harry Robinson built the first "estate" mansion above Sunset Boulevard. The Beverly Hills Hotel opened in 1912, and Rodeo Land and Water Company officials such as Burton Green, Max Whittier, and Charles Canfield showed faith by building their own homes in Beverly Hills. Green's mansion, built in 1914, set the standard for architectural splendor on three and a half acres at the northwest corner of Lexington Road and Crescent Drive, behind the Beverly Hills Hotel. It was a 20-room, Tudor-style mansion. The grounds were planted with full-grown oaks along a curved driveway to Lexington Road. Silsby Spalding had married Charles Canfield's daughter and, after Canfield's 1912 death, built a 30-room mansion called Grayhall on 54 acres in the hills above Green's estate. The house was modeled after an English country house, with a stone facade. In 1916, Max Whittier purchased four and a half acres at the northwest corner of Sunset Boulevard and Alpine Drive, where he built a 55-room, Italian Renaissance–style mansion that became a longtime landmark. It was sold to a young Saudi in 1978 but two years later was completely destroyed by fire.

Razor blade mogul King Gillette built a magnificent mansion on Crescent Drive just north of Sunset around 1917. In 1922, Gloria Swanson, who had lived at the Beverly Hills Hotel, purchased the estate. Famous architects designed many early mansions and buildings from the 1920s, including Gordon B. Kaufman, (architect of Greystone Mansion), Elmer Grey (Beverly Hills Hotel), Roland Coate (David Selznick and Jack Warner estates), and Robert Farquhar (Harry Cohn mansion on the corner of Lexington and Crescent Drives). The most popular Beverly Hills architects were Paul Williams, who desiged the famous Cord Estate on Doheny Road, and Wallace Neff, who designed 100-plus homes in Beverly Hills and Bel Air.

An example of the decline of Beverly Hills mansions in the 1960s occurred with the Cord Estate on Doheny Road, across from the Doheny Ranch. After the Cord family moved, the estate was torn down and subdivided. Well into the 1970s and after the Persian immigration of the 1980s, many of Beverly Hills estates were either demolished and subdivided or completely remodeled, as with the Green estate.

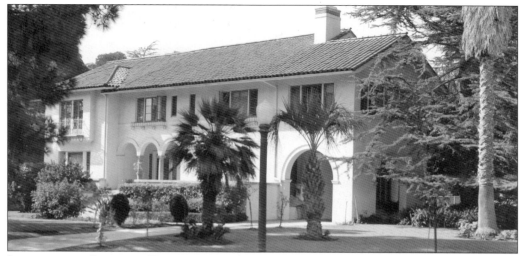

LOMITAS AND CRESCENT DRIVE, 1940. The Lomitas mansion was demolished in the 1990s to make way for a modern house. In 1906, planning architect Wilbur Cook divided the one-mile-wide strip of land between Santa Monica and Sunset Boulevards into four blocks, with the lots on each block generally getting larger and more expensive as they neared Sunset Boulevard and the hills. Between 1907 and 1920, mini mansions were being built in this area on prominent lots.

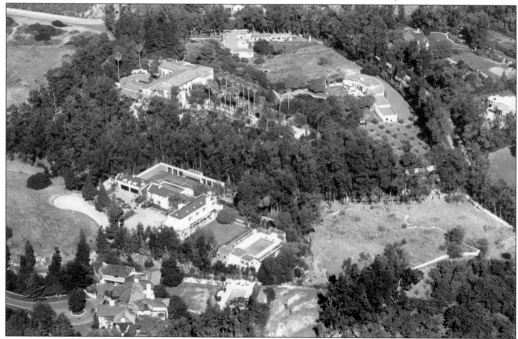

MILTON GETZ/DAVIES-HEARST ESTATE, 1948. The Getz estate (center with palm trees) at 1017 North Beverly Drive was built in 1927 as one of Beverly Hills most prominent estates at the time. The Spanish Mediterranean mansion was later purchased by Marion Davies for William Randolph Hearst in 1946. Hearst and Davies moved into the estate in May 1947, and in 1951, Hearst died there at the age of 89. Marion continued to live on the estate and loaned it to John F. Kennedy for his honeymoon retreat with bride, Jacqueline.

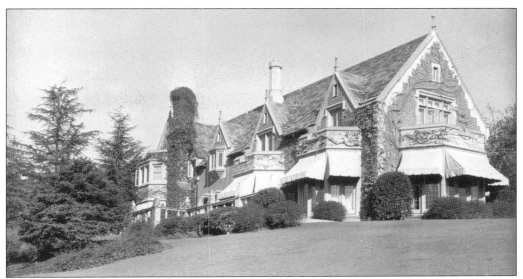

GEORGE B. LEWIS ESTATE, 1944. Built by industrialist George B. Lewis in 1925, the medieval English French-styled estate was one of the first major estates built in the western hills of Benedict Canyon. The 10-acre property on Angelo Drive was designed by architect Albert Farr and was featured in a 1926 *Architectural Digest*. For over 35 years, the estate was used by film companies as a location background until the entire property was subdivided into homesites in the 1960s.

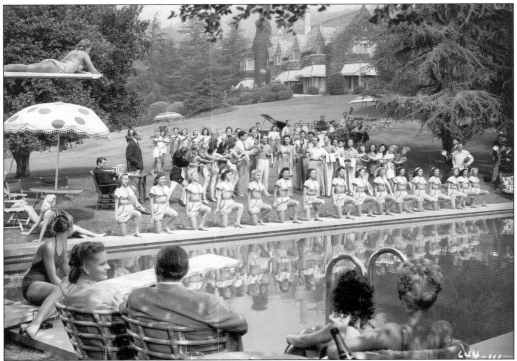

LEWIS ESTATE-WARNER BROTHERS FILM LOCATION, 1946. Warner Brothers Pictures brought the *Night and Day* production unit, which included Cary Grant and Alexis Smith, to the Lewis estate. Cary Grant plays Cole Porter in this film and can be seen seated to the right of the umbrella.

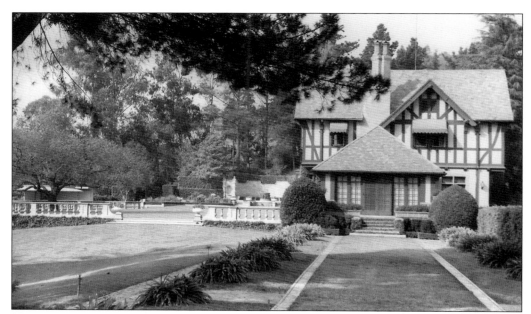

HARVEY MUDD ESTATE, 1952. Located at 1240 Benedict Canyon Drive, the Mudd residence, one of the oldest in the area, was built in 1922 as a country English Tudor mansion. The home has a two-story, carved wood and stone entry. It has Old World paneling and woodwork with beautiful landscaped garden grounds. The MGM Studios location department photographed the house and grounds in 1952 for the possibility of the property being used as a film location background.

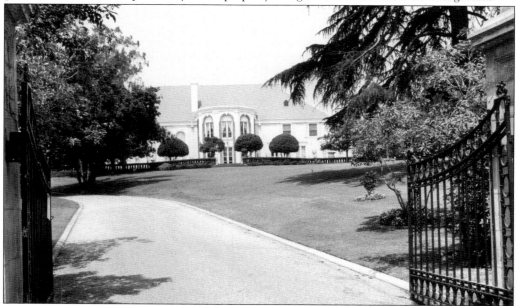

BURTON GREEN ESTATE, 1971. The estate is located on Lexington Road and was completed as one of the first major mansion estates north of Sunset Boulevard in 1914. Burton Green, one of the founders of Beverly Hills, was the first to install a swimming pool on his estate. The estate was completely remodeled by Eugene V. Klein, an owner of the San Diego Chargers in the late 1960s.

Seven

HOME OF THE STARS
1930–1990

Thomas Ince, one of Hollywood's most influential film studio moguls, built a unique Pueblo-style home in Benedict Canyon on 33 acres in 1924, using fantasy-style designs crafted in the Thomas Ince Studios art department. After Ince's November 1924 death, the founder of Universal Pictures, Carl Laemmle, purchased the estate and lived there until his death in 1936. Also in the 1920s, on a nearby hill overlooking the Ince Estate, Wallace Neff designed a two-story, Spanish-styled mansion for film director Fred Niblo. The house was laid out in almost a semicircle, and the bedrooms faced a circular stone-paved entrance court. The formal gardens featured an antique Roman sundial. In 1940, Niblo sold the estate to Jules Stein and his wife, Doris. Stein was the founder of the Music Corporation of America (MCA), which later took over Universal Studios. Media baron Rupert Murdoch bought the estate in 1986.

Some Beverly Hills homes have been occupied by more than one celebrity over the decades. Estates like Mary Pickford and Douglas Fairbanks's Pickfair at 1143 Summit Drive and Enchanted Hill, built by writer Frances Marion and actor Fred Thompson, were replaced by larger, more modern mansions. When the Irving Hellman and, later, the Roland Bishop estates at Oxford and Hartford Ways were subdivided in 1959, film actor Glenn Ford built a house on part of the property. The original stone wall of the Hellman-Bishop estate survives as a reminder of the estates of Beverly Hills pioneers.

Fred Astaire's home at 1155 San Ysidro Drive was built in 1960, and he lived there until his death. Fans of Lucille Ball came from around the world to see her home at 1000 North Roxbury Drive. Ball and Desi Arnaz bought this house in 1954; it was next door to Jack Benny. Charles Chaplin built a mansion at 1085 Summit Drive in 1922, calling it the "Breakaway" house, because film studio artisans partially built and decorated it. Demolished in recent times was the George Gershwin and, later, Rosemary Clooney home at 1019 North Roxbury Drive. In 1925, Marion Davies and William Randolph Hearst purchased an estate at 1700 Lexington Road. Near the Pickfair and Chaplin estates, Sammy Davis Jr. lived at 1151 Summit Drive from the early 1970s until his death. Marlene Dietrich lived in several historic homes in Beverly Hills; one located at 822 North Roxbury Drive in the early 1930s.

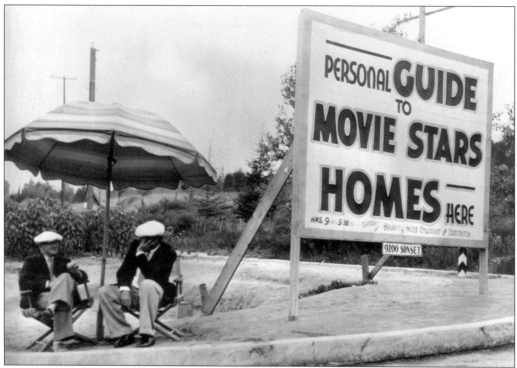

SUNSET AND DOHENY ROAD, 1936. At what is now the site of City National Bank, at the Sunset and Doheny Road intersection, was the place where one could buy a map to the stars' homes. Since 1920, when Douglas Fairbanks and Mary Pickford moved to the hills above the city, fans have been taking tour buses or driving to see where the stars lived.

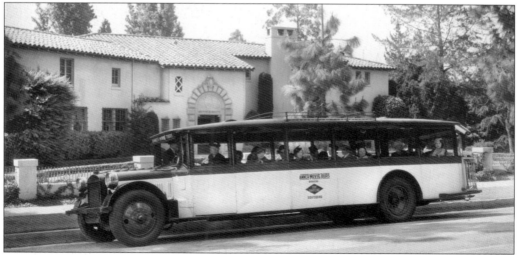

DR. NORMAN SPRAGUE ESTATE, 1930. Since 1920, there have been organized tours of the stars' homes in Beverly Hills. Here is the Grayline-Anner Movie Tours bus at the Sprague estate on Lexington Road, one of many grand mansions built in the early 1920s north of Sunset. Other estates, such as those owned by Marion Davies, Burton Green, Max Ahrens, Robinson Gardens, and Irving Hellman, were on or near Lexington Road.

CAROLE LOMBARD HOME, 1932. Movie magazines like *Photoplay* featured homes of the stars. Carole Lombard was on the verge of stardom and was working for Paramount as a featured player. One of her homes was this house at 620 Walden Drive when she was married to MGM actor William Powell.

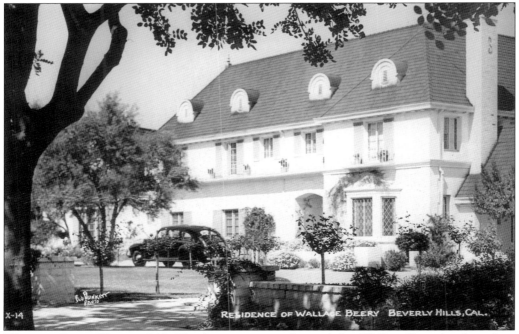

WALLACE BEERY HOME, 1948. This home was one of several that Wallace Beery lived in when he moved to Beverly Hills in the late 1920s. He also lived at 816 North Alpine and at 921 North Roxbury Drive in the early 1930s.

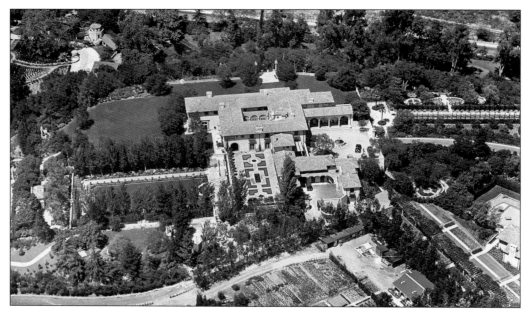

HAROLD LLOYD ESTATE, 1934. Harold Lloyd purchased a portion of the former Thomas H. Ince estate in Benedict Canyon in 1926 and embarked on building his dream home there. It took a couple of years to complete, and Harold and Mildred Lloyd moved into the estate in 1928. The Lloyd estate, Greenacres, was a 40-room mansion set on 22 acres at 1225 Benedict Canyon Drive. It was the most impressive and expensive of all the movie star estates ever built in Beverly Hills.

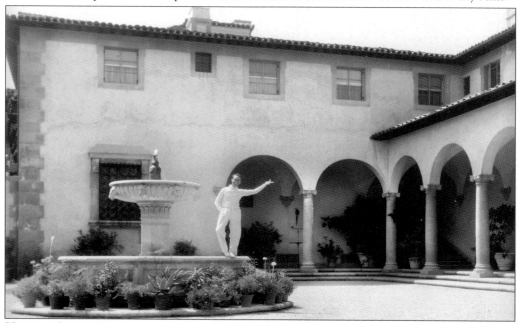

HAROLD LLOYD ESTATE, 1935. Harold Lloyd is standing on the entry courtyard fountain in front of Greenacres. The Italian Mediterranean mansion became one of Beverly Hills's most lavish estate landmarks. Lloyd made millions with his films that his own production company had produced. He could afford to live the lifestyle of a movie star.

GREENACRES, 1938. This is the rear view of the Harold Lloyd estate from the formal poplar gardens. The house was handmade, with many materials imported from Italy. The estate's gardens were extensive and were constructed on varied levels surrounding the main house. Built on a knoll, the mansion had pink stucco walls and a red-tile roof and was designed by John de Lario. The house occupied over 36,000 square feet.

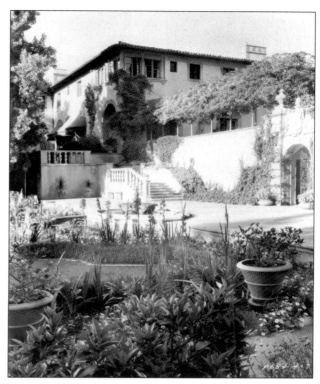

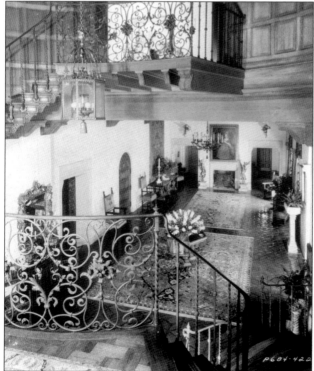

GREENACRES, 1938. In the entrance hall of the Harold Lloyd home, the handwrought iron staircase railing with wood paneling and tiled floors were the first to be seen when entering the main house. Custom-made fixtures in the Renaissance style were carefully placed in the grand reception foyer, which had a 16-foot-high ceiling.

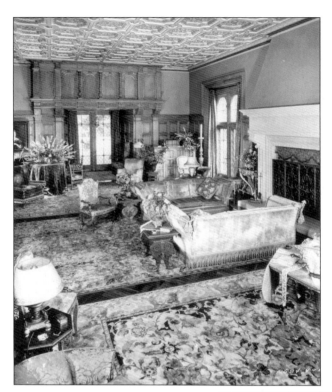

THE SUNKEN LIVING ROOM, 1938. The living room of the Lloyd home was adjacent to the entry hall and was furnished with fine paintings, antiques, an organ, and projection room with sound equipment for showing sound motion pictures. The gold leaf coffered ceiling was the showplace of the house.

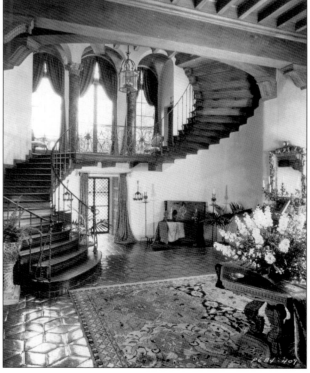

GREENACRES ENTRANCE HALL, 1938. The circular staircase was attached to the wall on one side but had no supports underneath the risers. The Romanesque arches, held up with neoclassical columns, formed one of the most impressive entry hall-foyers of any major estate in Beverly Hills.

EDWARD G. ROBINSON HOME, 1940. Robinson lived at 910 North Roxbury Drive for over three decades, making his home and Roxbury Drive one of the more popular tourist sites in Beverly Hills. It was here that Robinson collected one of the great Impressionist painting collections in the world.

MARLENE DIETRICH HOME, 1933. On the southeast corner at Sunset Boulevard, this art deco home at 822 North Roxbury Drive was built in 1928 by Charles Mack, of Moran and Mack, also known in the 1920s as The Black Crows because of the vaudeville act they performed in blackface. By 1932, Mack had put the house up for lease, not being able to afford living in his home any longer as the Depression took hold of the country. This was one of the first homes in Beverly Hills that Dietrich, a major star at Paramount, lived in.

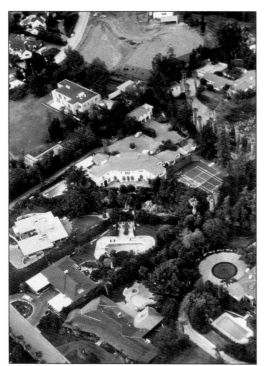

BUSTER KEATON ESTATE, 1961. Buster Keaton's dream house was built on a hill above Lexington Road on the northeast corner of Benedict Canyon. The Italian villa–style estate was a grand movie star home. The Keatons moved into the home at 1004 Hartford Way in 1925, not far from the Beverly Hills Hotel. The house is a 20-room mansion complete with library/projection theater room and outdoor swimming pool down a hill below the mansion. When this photograph was taken, the grounds had been subdivided into four home sites.

JACK WARNER ESTATE, 1990. This impressive Benedict Canyon property included a 13,600-square-foot neoclassical mansion furnished with antique furniture and decorations and set in 10 acres of gardens, fountains, pools, and tennis courts. Adjacent to Greenacres, both Warner and Lloyd had 9-hole golf courses that could be joined for an 18-hole game. In the 1980s, it was sold to David Geffen, who later remodeled the mansion to house his collection of modern art.

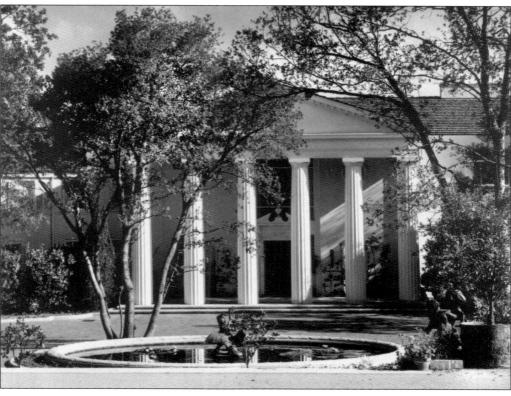

LUCILLE BALL AND DESI ARNAZ HOME, 1960. Ball and Arnaz purchased this home in 1954. They had been living in Chatsworth since the mid-1940s but wanted to be closer to the studio where their television show was filmed. The home at 1000 Roxbury Drive became a showplace for the tourists that came to see where Lucy lived.

GLENN FORD HOME, 1963. Glenn Ford purchased a lot in a subdivision of what was once the former Roland Bishop and later Irving Hellman estate at Oxford and Hartford Way and built his dream home there in 1959. Located at 611 Oxford Way, the modern-style house was state-of-the-art design at the beginning of the 1960s.

GROUCHO MARX HOME, 1962. Shortly after the Trousdale Estates were completed in 1957, prime lots were immediately sold. Several celebrities were already building homes there by 1960, and in 1962, Groucho built his contemporary home at 1083 Hillcrest Road, one of the prime lots. Groucho had been a longtime resident of Beverly Hills, having lived in several homes since the 1930s.

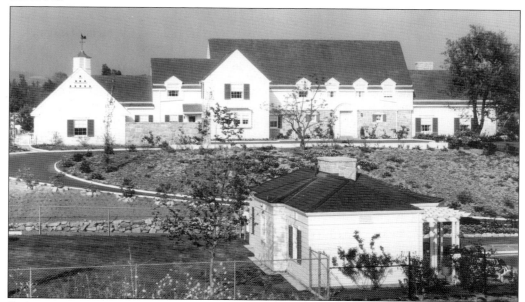

ROBERT MONTGOMERY HOME, 1938. Film actor Robert Montgomery wanted a city home in the country style and designed for himself a house in Bel Air that was patterned after his own farmhouse in upper New York. After living in several houses in Beverly Hills over three years, he moved into a Holmby Hills house until his new home was finished. Montgomery continued to be seen around Beverly Hills for many years until he moved to New York.

Eight

MOTION PICTURE
INDUSTRY
1930–2005

The motion picture and entertainment industries have maintained a close relationship with the city of Beverly Hills since Douglas Fairbanks and Mary Pickford became residents in 1921. Five beautiful motion picture theaters have operated in Beverly Hills—the Beverly Theater (1925), Warner Beverly Hills (1931), Fox Wilshire (1931), Regina (1935, later known as the Fine Arts), and the Music Hall (c. 1962). A film location since the early 1900s, Beverly Hills resembled international places of beauty and architectural significance. The Lasky Company filmed scenes for *The Unafraid* (1915) in Sunset Park, with the Beverly Hills Hotel in the background. By the 1950s, Rodeo Drive, stars' homes, and other Beverly Hills locations were continually recycled as backdrops for films, television shows, photographic shoots, and industry events. The hotels, streets, and homes have continually publicized Beverly Hills on an international basis.

Contributing to the folklore of Beverly Hills have been Marilyn Monroe, Elizabeth Taylor, John F. Kennedy, Joseph P. Kennedy, Gloria Swanson, Lana Turner, Frank Sinatra, Bugsy Siegel, E. L. Doheny Jr., and Howard Hughes, among many others. Sites associated with movie people include Will Rogers Memorial Park, several famous churches, and Greystone Mansion, a popular film location since *Forever Amber* (1947), starring Linda Darnell and Cornel Wilde. Lensed at Greystone and on its grounds were *Dead Ringer* (1964) with Bette Davis, *The Disorderly Orderly* (1964) with Jerry Lewis, *The Loved One* (1965), *Ghostbusters* (1984), *X-Men* (2000), *Batman and Robin* (2001), *Spider-Man* (2001), and *Charlie's Angels 2* (2003). Greystone was also the background for such television series as *Dynasty, Falcon Crest, Knots Landing, Dark Shadows, McCloud,* and *Columbo.*

In 1926, the Willat Productions Studio administration building, designed by motion picture art director Harry Oliver as a fantasy-style cottage, was moved to Beverly Hills from Culver City. Later known as the Witches House, it remains one of the city's most popular landmarks. The Church of the Good Shepherd at 505 North Bedford Drive is a famous landmark, and its parishioners have included Desi Arnaz, Rosemary Clooney, Gary Cooper, Jimmy Durante, Jose Ferrer, Carmen Miranda, and Loretta Young. In May 1950, Elizabeth Taylor was married to Conrad N. Hilton Jr. there. The church also became internationally famous for Rudolph Valentino's 1926 funeral. Rodeo Drive's bridle path was used for horse-related scenes. Rodeo Drive, South Santa Monica Boulevard, and the business triangle were all backgrounds for such films as *Body Double* (1984), *Clueless* (1995), and *Pretty Woman* (1990).

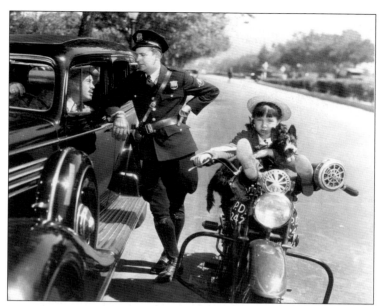

SUNSET BOULEVARD LOCATION, 1935. Twentieth Century Fox actress Jane Withers (on the motorcycle with her dog) is in a scene from *Paddy O'Day* with Robert Dudley as the chauffeur and Russ Clark as the motor officer. Jane plays an Irish girl going to live with a wealthy family in Southampton, New York. Beverly Hills doubles for Southampton. Note the Sunset Bridle Path at the top right of the photograph.

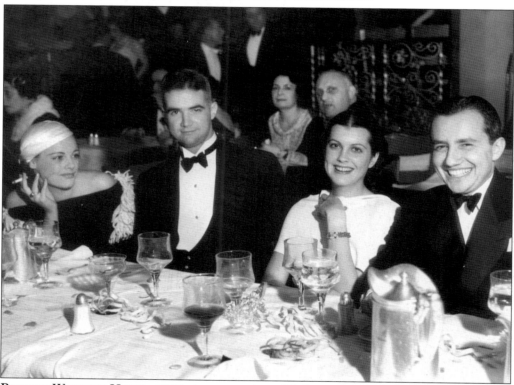

BEVERLY WILSHIRE HOTEL, 1933. A cross section of Hollywood was invited to the Clark Gable party in August 1933. When the Beverly Wilshire Hotel opened in 1928, it was the second major hotel to attract Hollywood celebrity partygoers to Beverly Hills. The Gable party included, from left to right, Eleanor Holm, Howard Hughes, Sandra Shaw, and Universal Studio's head of production, Carl Laemmle Jr.

BEVERLY HILLS HOTEL TENNIS COURTS, 1935. Beverly Hills Hotel tennis instructor Harvey Snodgrass was popular among the Hollywood celebrity colony. Here is Snodgrass with actress Jean Harlow, who was among several stars who took instruction.

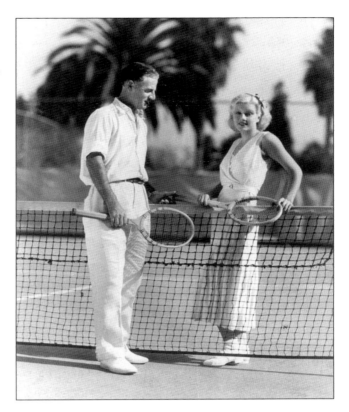

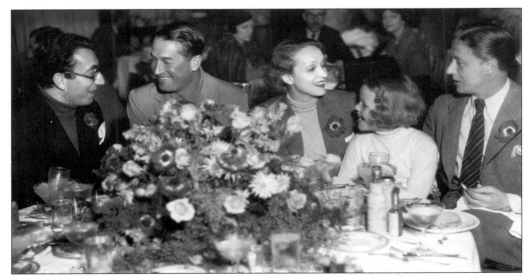

BEVERLY HILLS HOTEL PARAMOUNT PARTY, 1932. A party celebrating the release of the film *Love Me Tonight*, starring Maurice Chevalier, was held at the hotel with Paramount stars in attendance. Pictured here, from left to right, are Rouben Mamoulian, director of the film; Maurice Chevalier; Marlene Dietrich; her daughter Maria; and her husband, Rudolf Sieber.

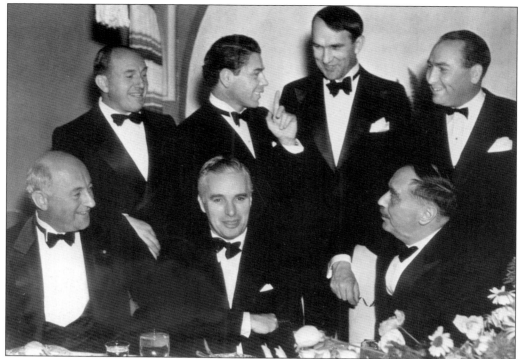

H. G. Wells Party, 1933. Famed writer H. G. Wells was honored for his new book, *The Shape of Things to Come*, at the Beverly Hills Hotel to confront fascism before it was too late. Friends of Wells, from left to right, included (first row) Cecil B. DeMille, Charles Chaplin, and H. G. Welles; (second row) Jack Warner, Paul Muni, unidentified, and Hal B. Wallis.

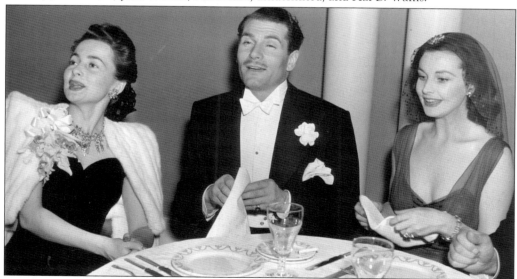

Beverly Wilshire Hotel Dining Room, 1940. Beverly Hills was known as the Hollywood to the west since many celebrities were residents or could be seen frequently shopping or being entertained at the city's business establishments. Pictured here at the Beverly Wilshire are Olivia de Havilland, Laurence Olivier, and his wife, Vivien Leigh.

BEVERLY HILLS HOTEL POOL AREA, 1938. The Beverly Hills Hotel was used by Hollywood for publicity. Stars posed in and around the hotel grounds to promote films or fashions. Lucille Ball wears an "ensemble worn here which was created for her use in the RKO film, *Go Chase Yourself* and is ideally adapted for summer wear. The geometrical design reflecting shades of blue, ranging from light to very dark blue is topped with a pleated skirt and a yellow straw hat."

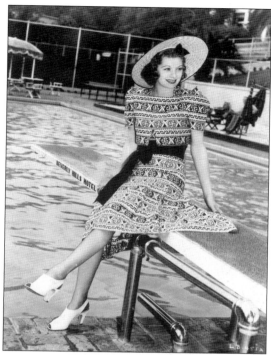

LORETTA YOUNG IN HER NEW HORSE AND BUGGY, 1942. At the beginning of the war, citizens were asked to save on gasoline for the war effort. Loretta Young leased a horse and buggy to demonstrate the saving of fuel by doing her business in town without an automobile. Young is seen at the intersection of Burton Way and Canon Drive causing a minor traffic jam.

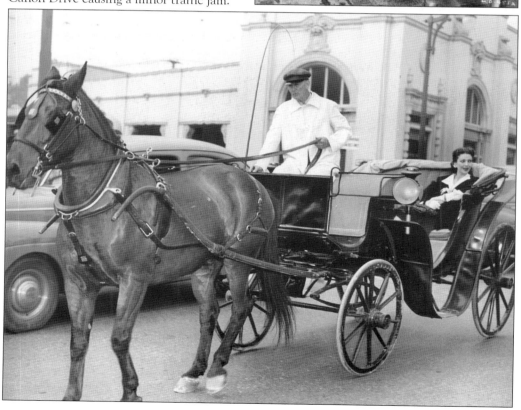

TYRONE POWER AT SUNSET PARK IN 1952. Film actor Tyrone Power pays a visit to Sunset Park, renamed Will Rogers Memorial Park in honor of Will Rogers, who died in a plane crash in 1935. Power knew Rogers during the time they were both top stars at 20th Century Fox studios.

SUNSET PARK, 1947. Celebrity residents could be seen at any time, making Beverly Hills truly the "City of the Stars." Here Rosalind Russell spends some quality time with her children at the park. The Columbia Studios publicity department routinely followed stars around town for human-interest stories. Russell was starring in her latest film release, entitled *The Guilt of Janet Ames*. Russell is pictured here with "Missey" Murphy, daughter of actor George Murphy, and her son, Lance.

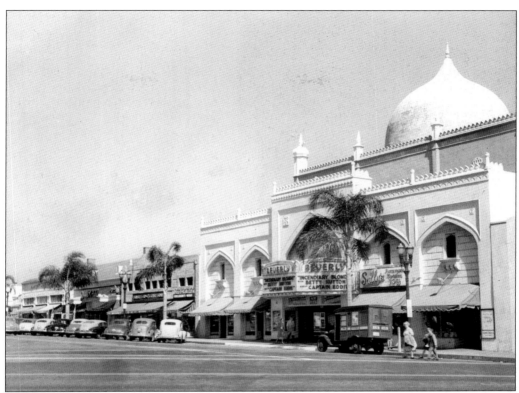

FOX BEVERLY THEATER, 1945. Located at 206 North Beverly Drive at Wilshire Boulevard, the current film playing at the theater was Paramount's *Incendiary Blonde*, starring Betty Hutton. In 1925, real estate pioneer Dan M. Quinlan constructed the theater, the first to be built with East Indian decor. The businesses in the theater building included Sally's Homemade Candies.

SUNSET BRIDLE PATH, 1949. Columbia star Larry Parks, with his wife, stage and screen star Betty Garrett, are seen standing at one of the entrances to the bridle path at Beverly Drive and Sunset Boulevard. At this time, Parks was starring in *Jolson Sings Again*, playing the famous Al Jolson. In 1930, the city of Beverly Hills banned horseback riding within the city limits, and to keep the path active, bicycle riding was encouraged. By 1958, the bridle path was taken out and a center median of grass and plants were substituted.

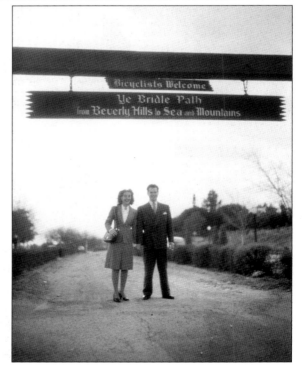

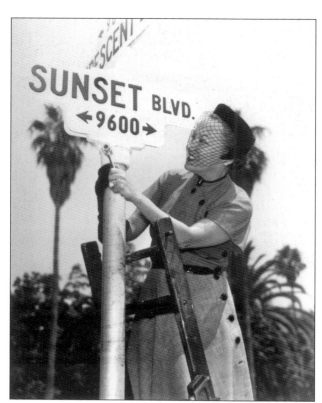

NEW BEVERLY HILLS STREET SIGNS, 1950. Gloria Swanson officiated a ceremony marking the completion of the installation of nearly 900 new street signs. The dedication was held at the corner of Crescent Drive and Sunset Boulevard, where Gloria Swanson once owned the old King Gillette estate on the northeast corner of Sunset and Crescent Drive. She was chosen to be the master of ceremonies due to her new film *Sunset Boulevard* being released at the time.

ROBINSON'S DEPARTMENT STORE FILM LOCATION, 1956. Columbia stars Aldo Ray and Anne Bancroft appear on location at Robinson's in Beverly Hills. A caption on the photograph said, "Odd Getaway . . . pursued by killers, Aldo Ray picks up the skirt bound fashion model, Anne Bancroft, so that they can make a quick getaway in *Nightfall* for Columbia."

MGM Studio Film Location at the Beverly Hills Hotel, 1956. The caption on the rear of this photograph read, "Party Pool . . . Gregory Peck and Lauren Bacall . . . have fun around the Beverly Hills Hotel pool for one of the exterior scenes in MGM's *Designing Woman*. This is a story about a sportswriter, a fashion designer and an actress that was directed by Vincente Minnelli and produced by MGM studio head Dore Schary."

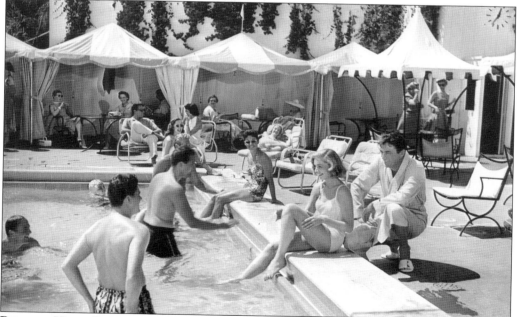

Beverly Hills Swimming Pool and Cabanas Film Location, 1956. Gregory Peck and Lauren Bacall appear in a scene at the pool for the MGM film *Designing Woman*. When films were shot in and around Beverly Hills landmarks, tourist traffic would increase in the city due to the international publicity such films generated.

The Beverly Canon Theater, 205 North Canon Drive, 1956. The Beverly Canon Theater was the only independent legitimate theater in Beverly Hills, opening in 1945. The theater was a popular venue for 60 years until it was demolished in 2005 to make way for a hotel project. Many popular off-Broadway shows were staged at the small theater with great success. Known internationally as a local cultural center, it became a landmark in Beverly Hills.

The Music Hall Theater, 1962. Located at 9036 Wilshire Boulevard, one block east of Doheny Drive, the theater showcased many varied films from features to documentaries. Between 1953 and 1955, the theater was leased by Lee and George Liberace for *The Liberace Show* on NBC. The Music Hall is now the second oldest continually operating cinema theater in Beverly Hills.

THE FINE ARTS THEATER, 1959.
Located at 8556 Wilshire Boulevard, one block west of La Cienega, the theater was once known as the Regina Theater, which opened in the mid-1930s. The Fine Arts Theater has been a popular neighborhood theater, playing foreign and American films into the new millennium. The art deco-style theater is a Beverly Hills landmark, originally one of the five cinema theaters in the city since 1925.

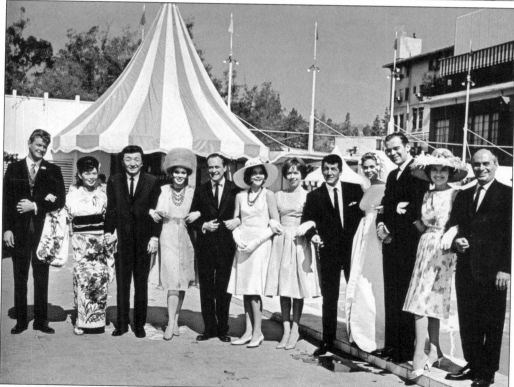

BEVERLY HILLS HOTEL POOL AND CABANA FILM LOCATION, 1963. Paramount used the Beverly Hills Hotel for the comedy *Who's Been Sleeping In My Bed?* This photograph shows star Dean Martin and the cast by the pool for the wedding scene in the film. Pictured here, from left to right, are Johnny Silver, Yoko Tani, Jack Soo, Jill St. John, Louis Nye, Macha Maril, Carol Burnett, Dean Martin, Elizabeth Montgomery, Elliott Beid, Elizabeth Frazer, and Martin Balsam.

TROUSDALE ESTATES FILM LOCATION, 1964. Jerry Lewis, the star of the Paramount film *The Disorderly Orderly*, is seen here on Loma Vista Drive in a scene from the film. Most of the film was shot at Greystone mansion, which appears predominately in the film.

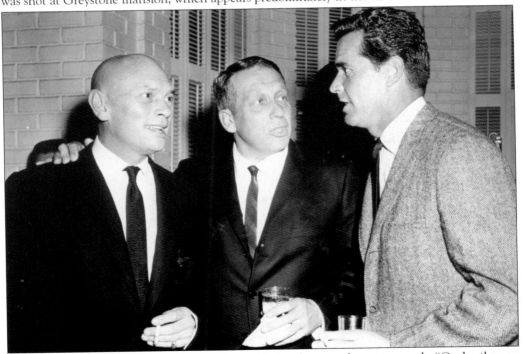

BEVERLY HILLS HOTEL PARTY, 1964. This publicity photograph caption reads, "Cocktail party at the Beverly Hills Hotel, November 9, 1964, where Mr. George Weltner, President of Paramount Pictures Corp., announced that Mr. Howard W. Koch, Paramount Production and Studio Head, has been made a Vice President of the company." The guests included Yul Brynner, Howard W. Koch, and James Garner.

BEVERLY DRIVE FILM LOCATION, 1969. When the television show *The Beverly Hillbillies* appeared on national television, Beverly Hills was again showcased around the world as the background. Here *The Beverly Hillbillies* family rides in their truck on Beverly Drive and Elevado in the opening sequence of the comedy series. The cast members in the truck include Buddy Ebsen, Irene Ryan, Donna Douglas, and Max Baer Jr.

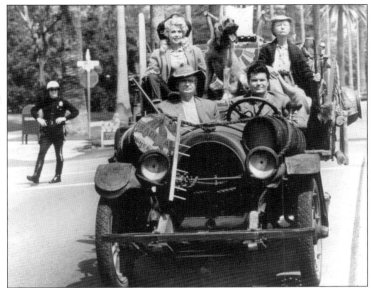

BEVERLY HILLS HIGH SCHOOL FILM LOCATION, 1977. Steve Guttenberg and Lisa Reeves appear in a scene from the Avco Embassy film, *The Chicken Chronicles*, at Beverly Hills High School. The school has been used for filming since the 1930s. When a new swimming pool with an electric retracting floor was installed in the gym, Frank Capra shot one of the most famous scenes in film history there for *It's a Wonderful Life* (1946).

PARAMOUNT LOCATION IN BEVERLY HILLS, 1987. The stars of *Beverly Hills Cop II*— Judge Reinhold, John Ashton, and Eddie Murphy—appear in many scenes shot in and around Beverly Hills. With the release of *Beverly Hills Cop* in 1984, the city of Beverly Hills was showcased around the world and the city was publicized as the "City of the Stars."

THE BEVERLY THEATER, 2005. This is the last view of the 80-year-old Beverly Theater before it was demolished to make way for a new hotel project. The famous, iconic onion dome of the former East Indian–designed theater had collapsed, and by the beginning of 2006, the theater would no longer exist as one of the most enduring landmarks in Beverly Hills and Los Angeles.

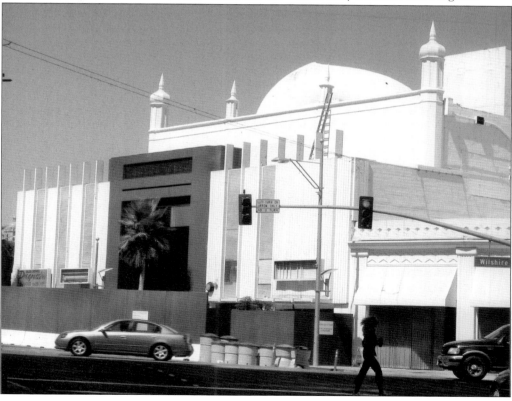

Nine

Restaurants in Beverly Hills
1930–1970

The movie colony in Beverly Hills was at the height of its popularity and wealth during the 1930s, when many movie people moved in from Los Angeles and Hollywood. The Brown Derby opened in 1931 at Wilshire and Rodeo Drive, giving the Beverly Hills movie colony their own "Derby." The first exclusive and expensive eatery to open in Beverly Hills was Victor Hugo Restaurant. Long a popular first-class establishment in downtown Los Angeles, the business moved to Beverly Hills in December 1934. Other 1930s restaurants included Armstrong-Shroder Café, Carpenters Drive-In, McDonnells Drive-In, and the Wilshire Coffee Pot. The car culture was evident with the opening of Harrold's, a "Park & Eat" restaurant. During the 1930s, most Beverly Hills residents frequented the Trocadero, Maxime's, and Mocambo club-restaurants on the Sunset Strip, adjacent to where they lived.

Former vaudevillian Dave Chasen opened a Southern Pit Barbecue on the West Hollywood-Beverly Hills border on December 13, 1936. This small, six-table restaurant turned into one of the world's most famous restaurants—Chasen's. Also in December 1936, Harry Sugarman, a motion picture theater operator, opened The Tropics at 421 North Rodeo Drive. The advertisements in the media said, "Sugie, your host, invites you to Beverly Hills and his informal dining rooms and cocktail lounge of the motion picture industry." The popular Weiss' Hungarian Inn opened at 330 North Rodeo Drive in 1932 in a little house on that street.

One of the most famous of the Beverly Hills restaurants was Romanoff's, which opened at 325 North Rodeo Drive on December 19, 1940. Mike Romanoff gathered together celebrity investment in his new establishment. The most prominent drive-in in Beverly Hills was Simon's (formerly McDonnell's) on Wilshire Boulevard. Postwar growth continued with the opening of new restaurants catering to an influx of residents. During the 1950s, the most popular restaurants in Beverly Hills were The Luau, Melody Lane, Blum's, Trader Vic's, and on "Restaurant Row" along La Cienega Boulevard were Richlor's, Lawry's, Sarnez, Frascati Inn, and Dolores Drive-In at Wilshire.

With the coming of the 1960s and 1970s, more landmark restaurants continued the tradition of fine food and social events, including The Bistro on Canon Drive, Ah Fong's, Nate 'N' Al's, Candy Store, Nibblers, Andre's, Jacopo's Pizzeria, El Padrino Bar (Beverly Wilshire Hotel), La Scala, Blum's, Magic Pan, Maison Gerard, Old World, and the Benihana of Tokyo. The 1980s and 1990s saw the decline of some of the area's traditional restaurants.

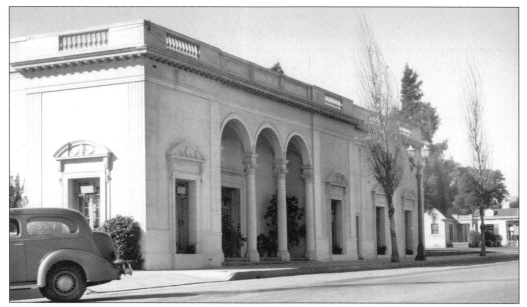

VICTOR HUGO RESTAURANT, 1938. Located at 233 North Beverly Drive on the west side of the street, the Victor Hugo Restaurant opened a branch in Beverly Hills in December 1934. Its original site was very popular in downtown Los Angeles well into the 1930s. By 1942, the restaurant had closed and was completely remodeled into the famous Adrian's Couture showroom, bringing high fashion to Beverly Hills.

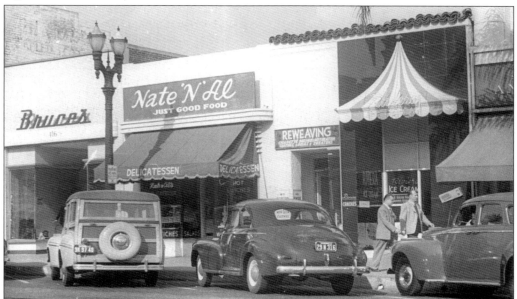

NATE 'N' AL'S DELICATESSEN AND RESTAURANT, 1947. One of the most enduring Beverly Hills restaurants is Nate 'N' Al's, located at 414 North Beverly Drive since 1945. In May 2005, the restaurant celebrated its 60th anniversary. Al Mendelson and Nate Reimer opened the delicatessen to a celebrity clientele typical for Beverly Hills. From Jack Benny to violinist Jascha Heifetz, almost every celebrity resident or visitor has eaten at Nate 'N' Al's over the years.

ROMANOFF'S RESTAURANT, 1949. The original Romanoff's was opened in December 1940 by Michael Romanoff and was located at 326 North Rodeo Drive. The restaurant became the gathering spot for the Hollywood colony in Beverly Hills. In 1951, Romanoff's moved to 140 South Rodeo Drive, and by 1957, the Friars Club had taken over the north Rodeo Drive site. In 1961, the Friars Club moved to their current location. With the coming of the 1970s, the old Romanoff's building became the Daisy, a restaurant-nightclub with disco dancing.

ROMANOFF'S, 1949. Mike Romanoff's interior was the inner sanctum of Prince Mike, who is seen in the foreground of the photograph. The interior design of the flowers and leaves wallpaper was orange, green, and yellow. Romanoff started the restaurant with investment money of $7,500 each from friends such as banker Harry Crocker, Cary Grant, Darryl F. Zanuck, and studio financier John Hay Whitney.

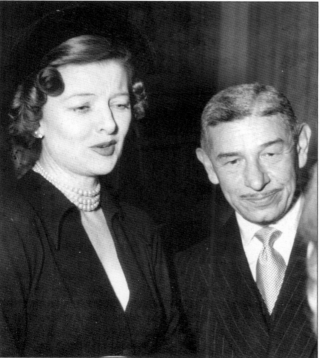

ROMANOFF'S, SOUTH RODEO DRIVE, 1956. In 1951, the new Romanoff's restaurant, located at 140 South Rodeo Drive, was a more modern version of the old location. The interior was composed of large, deep booths with an open feel, typical of the 1950s style of interior design. Of course, the clientele followed Mike to his new restaurant, and it flourished there until 1962 when it closed.

ROMANOFF'S OPENING PARTY, 1951. Myrna Loy is a guest of Mike Romanoff at his new restaurant location. Many of Mike's Hollywood friends attended, including James Stewart, Cary Grant, Darryl F. Zanuck, Dave Chasen, and Lauren Bacall, among others.

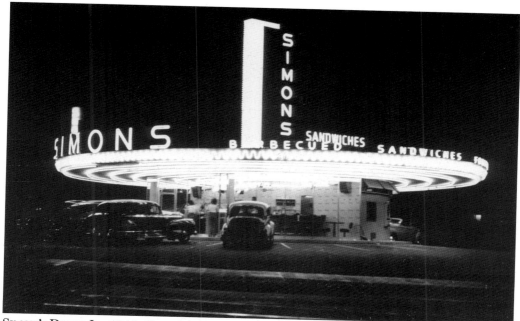

SIMON'S DRIVE-IN, 1940. One of the more unique drive-in restaurant designs was the new round Streamline Moderne Simon's Drive-In at Wilshire and Linden Drive that opened in December 1940. Over the years, Simon's was a popular hangout for Beverly Hills High School students; it was only a few blocks away.

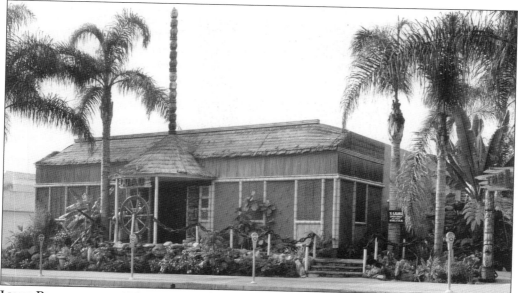

LUAU RESTAURANT, 1953. Opened in 1953 at 421 North Rodeo Drive by Steve Crane, who was married to Lana Turner, the Luau occupied the former site of Sugie's Tropics. It became one of Beverly Hills's most unique architectural landmarks with its trademark tiki decor. Friends of Steve Crane who were regulars included Ann Miller, Gene Kelly, Kathryn Grayson, Linda Darnell, and many others. In December 1979, the Luau was demolished to make way for the Rodeo Collection shopping mall.

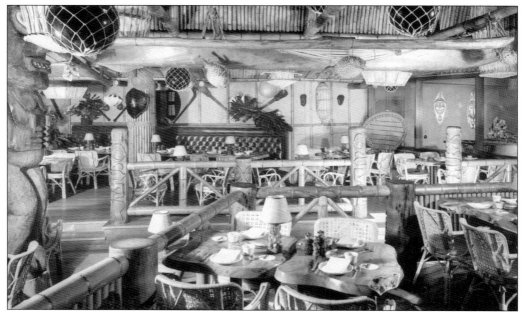

LUAU RESTAURANT, 1953. The interior was designed in "fantasy-south sea islands" decor that delighted all who patronized the Luau. An advertisement of the Luau announced, "A veritable Bali Ha'i in which to spend some enchanted evening! Celebrities flock to enjoy the truly spectacular Polynesian and Cantonese delicacies . . . exotic rum concoctions . . . unusual, light after-theatre snacks. Luncheon, dinner, and supper from noon 'til 1:30 a.m."

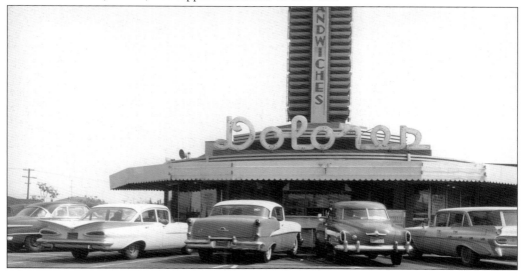

DOLORES DRIVE-IN, 1960. Located at 8531 Wilshire Boulevard, a block west of La Cienega, Dolores was opened in 1946 by Ralph and Amanda Stephens. The drive-in had male carhops, a special feature of hiring war veterans. During the postwar years, celebrities would drive out to Dolores for the pecan pie that became a trademark of the restaurant. Gregory Peck was one of the restaurant's best customers. Tyrone Power rubbed fenders with Linda Christian and Susan Hayward along with character actor Ward Bond, who would stop in for the hot coffee that was so popular. By 1981, Dolores Drive-In was demolished to make way for an office building.

THE BISTRO RESTAURANT, 1964. Kurt Niklas, the manager and maitre d' of Romanoff's on Rodeo Drive found himself out of a job when the famed restaurant closed in 1962. Several of the regular customers suggested that Kurt open his own restaurant with investment funds from a group of celebrity patrons. Famed director Billy Wilder helped put together a group of investors that included Jack Warner, Otto Preminger, Jack Benny, Sammy Cahn, and Swifty Lazar. The Bistro opened on November 1, 1963, at 246 North Canon Drive with many world famous celebrities in attendance.

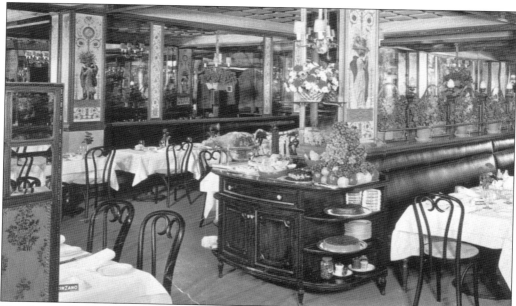

THE BISTRO RESTAURANT, 1964. At first, the interior design was supposed to be a replica of the set from the film *Irma La Douce,* as suggested by investor Billy Wilder. After a compromise, the interior was modeled after the famed Brasserie Lipp and Le Grand Vevour in Paris, France, and the exterior was a replica from the set of *Irma La Douce.* Fans of the restaurant included Henry Kissinger, Peter Lawford, Walter Matthau, Jack Lemmon, Lew Wasserman, and many others. Beverly Hills lost another famous landmark when the Bistro closed its doors in January 1994.

ONTRA CAFETERIA, 1965. The Ontra Cafeteria/parking structure building on the southwest corner of Beverly Drive and Dayton Way was once located at 725 North Beverly Drive. At the end of the 1950s, a new kind of cafeteria-style restaurant was making a resurgence, again following the lead of Cliftons in downtown Los Angeles. The Ontra advertisement in the 1961 restaurant guide announced their location in Beverly Hills. In a 1964 restaurant guide, the Ontra slogan said, "For Value and Variety in good eating." In the 1960s, Ontra cafeterias had eight other locations in the Los Angeles.

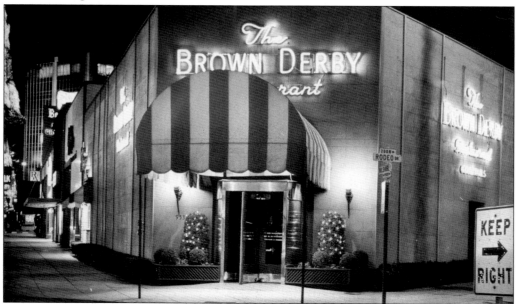

BEVERLY HILLS BROWN DERBY, 1972. The Brown Derby of Beverly Hills was established on the northwest corner of Wilshire Boulevard and Rodeo Drive at 9537 Wilshire Boulevard in 1931 and remained as a Beverly Hills landmark until it closed in 1982. For many years, Robert Cobb was the president. The Derby was completely remodeled and redecorated in the 1950s. A 1976 advertisement said, "Caricatures of T.V. and motion picture greats line the walls." (Artist Nicholas Volpe created a new tradition of celebrity caricatures that were hung in the restaurant in 1962.) Another 1976 advertisement announced, "40 years ago the Brown Derby offered the best 'blue plate special' in town. We still do! 'Meet me at The Derby'."

AH FONG'S RESTAURANT, 1963. Character actor Benson Fong opened his restaurant in Beverly Hills where the clientele was predominately from the Hollywood colony. In 1955, Ah Fong's was located at 466 North Beverly Drive, just south of South Santa Monica Boulevard. Throughout the 1960s and 1970s, Ah Fong's was the most popular Chinese restaurant in Beverly Hills, with celebrities and residents both regular customers. The building might not have been an architectural landmark, but Ah Fong's became a cultural meeting place until it closed in the 1980s.

HOUSE OF MURPHY, 1946. Located on "Restaurant Row" at 420 South La Cienega, The House of Murphy was opened by Bob Murphy around 1939. Murphy called his restaurant, "The only New York chop house on the pacific coast." By 1946, a script sign near the front entrance read, "Bob Murphy Wants To See You!" By the end of the 1950s, the House of Murphy closed.

THE MING ROOM, 1953. Bruce Wong opened one of the earliest Cantonese Chinese restaurants on Restaurant Row at the end of the 1940s. Like many of the restaurants on La Cienega at that time, the Ming Room was very popular among Beverly Hills residents, as well as a celebrity clientele for awhile. It closed sometime in the 1960s.

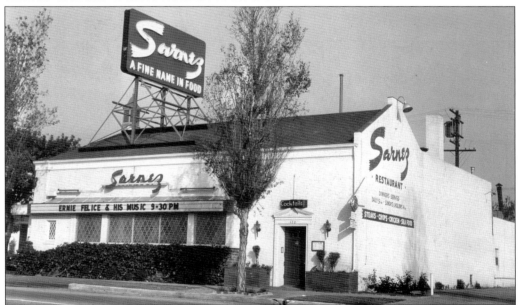

SARNEZ RESTAURANT, 1949. Sarnez opened as a steak and chop house on La Cienega, joining several other early restaurants after the war that formed what was known as "Restaurant Row." Ernie Felice supplied the musical entertainment for dining and dancing. Sarnez was known as "A Fine Name in Food, the smart place to go." It closed sometime in the 1960s.

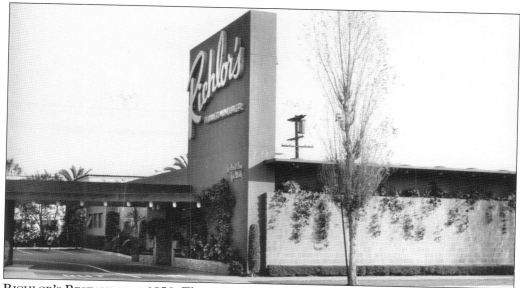

RICHLOR'S RESTAURANT, 1950. This restaurant building was built in 1941 by Lawrence Frank, cofounder of Lawry's Prime Rib, just north of his original La Cienega restaurant. He called it Richlor's after his son Richard and daughter Lorraine. Located at 156 North La Cienega Boulevard, Richlor's was known for its planked hamburger steaks and for its unique seafood bar. In the 1960s and 1970s, the restaurant became the Mediterrania, and in 1986, the building became the popular restaurant Ed Debevic's, which closed in the 1990s.

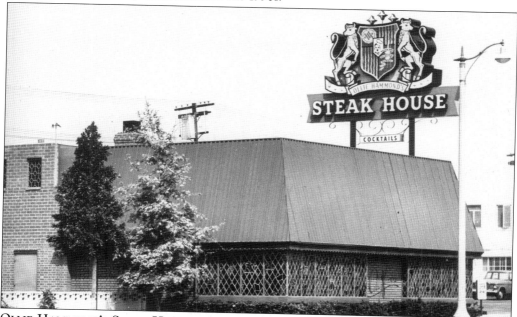

OLLIE HAMMOND'S STEAK HOUSE, 1972. Originally the restaurant opened in the Town and Country shopping center on Third Street in the early 1940s; the new location on La Cienega became a Restaurant Row landmark for many years. Located at 91 North La Cienega Boulevard, the new restaurant became another Restaurant Row landmark. Ollie Hammond's closed its doors in 1979.

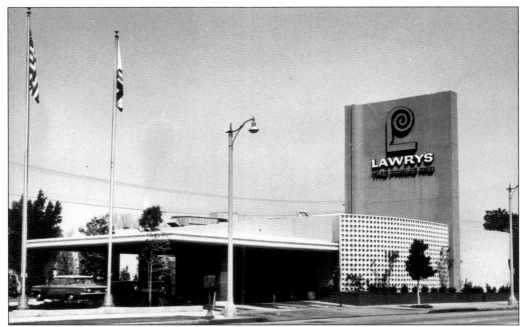

LAWRY'S PRIME RIB, 1972. Lawry's was created in 1938 as Lawry's Prime Rib by Lawrence Frank, a cofounder of the Van de Kamp chain of bakeries. His wife was a Van de Kamp. The first location was at 150 North La Cienega, previously occupied by two failed restaurants. After the war, Frank moved the restaurant to a larger, more modern building at 55 North La Cienega Boulevard.

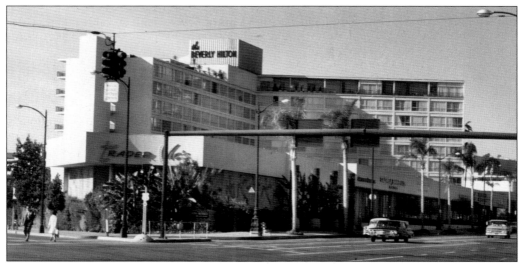

BEVERLY HILTON HOTEL, 1964. Opened in 1955, the Hilton was the third major hotel in Beverly Hills since the 1920s. The Hilton's 450 rooms, with private balconies, ballrooms, restaurants, and stores, created a new little city within a city on the western border of Beverly Hills. In 1959, at the Star on the Roof club/restaurant, George Liberace and his orchestra were the headliners. In 1968, the hotel advertised the Grand Ballroom, Versailles, Monte Carlo-Monaco-Royal-Fountain-Empire-Grand Salon, and Fountain Lanai and restaurants such as Trader Vic's, L'Escoffier, Star on the Roof, and the Gaslight Club.

Ten

FIFTY YEARS OF CHANGE
1950–2005

In the 1950s, the city of Beverly Hills comprised an area of 5.6926 square miles with a population of around 31,000. The public schools at this time included Beverly Vista, El Rodeo, Hawthorne, Horace Mann, and Beverly Hills High School. A new YMCA and J. W. Robinson's opened on February 11, 1952, at Wilshire and Santa Monica Boulevards. In the following year, the official city seal was designed and adopted by the city of Beverly Hills, and Frank Lloyd Wright designed Anderton Court at 322 Rodeo Drive. In 1955, the Beverly Hilton Hotel opened and work began on Trousdale Estates (the Doheny Ranch), the largest housing development in Beverly Hills history. In 1959, Gibraltar Square opened. Around the same time, groundbreaking took place for the memorial sculpture to honor film pioneer residents of Beverly Hills at south Beverly Drive and Olympic Boulevard. The ceremony was attended by many longtime Beverly Hills residents and celebrities.

By 1961, the Beverly Hills population increased to about 31,800, and in January 1964, Beverly Hills celebrated its 50th anniversary. In 1965, the Beverly Hills Public Library opened a new building on Rexford Drive. In the fall of 1969, Litton Industries took over the landmark building of 18th-century, Georgian Colonial architecture at Crescent and Burton, formerly the MCA building designed by architect Paul Williams in 1937. Perpetual Savings opened their architecturally notable headquarters on Wilshire Boulevard in 1971. The grand opening of the Great Western Savings Center was in 1972 at Wilshire and La Cienega. Fred Hayman launched the Beverly Hills fragrance Giorgio Beverly Hills in 1981. The 1980s brought Neiman-Marcus to Beverly Hills and Bijan, and the Rodeo Collection, a multilevel shopping center, was constructed on Rodeo Drive. The 1990s brought more development to the city, with the opening of Two Rodeo Drive at the corner of Wilshire and Rodeo. The Academy of Motion Picture Arts and Sciences opened their Center for Motion Picture study in the old Beverly Hills Waterworks building on La Cienega. The premiere of the television show *Beverly Hills 90210* brought international attention to Beverly Hills. The Peninsula Hotel was built in 1991, adding another first-class hotel to the city, and in 1995, the Beverly Hills Hotel was renovated and reopened.

In 2005, the last major historic site that was demolished for further development was the Beverly Theater at Beverly Drive and Wilshire Boulevard. Built in 1925, the 80-year-old theater building, with its signature Indian temple dome, had become an international icon of Beverly Hills.

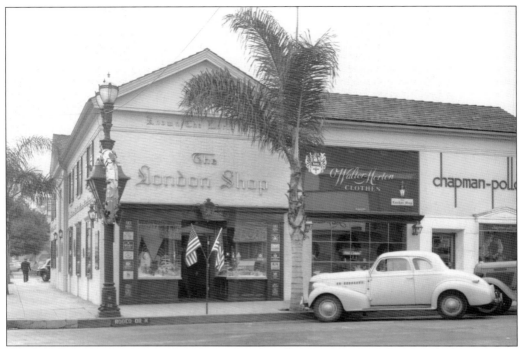

DAYTON WAY AND RODEO DRIVE, 1947. Beverly Hills was in a postwar boom with the growth of its population and the economy on the rise. Shops such as The London Shop and the Chapman-Pollock tailors were located on the southeast corner of Dayton Way and Rodeo Drive.

BURTON WAY (SOUTH SANTA MONICA BOULEVARD), 1947. Looking east toward Canon Drive, South Santa Monica Boulevard was an extension of Burton Way. On the right where the drugstore is located was the original shopping building of Beverly Hills, established in the early 1920s.

RODEO DRIVE AND BRIGHTON WAY, 1951. As late as the 1950s, there were still small bungalow houses on Rodeo Drive. Pictured here is the Joseph Reppac Famous Spaghetti Restaurant, located in one of the small houses on the southwest corner of Brighton Way. It was not until the end of the 1950s that Rodeo Drive began to look like a commercial street.

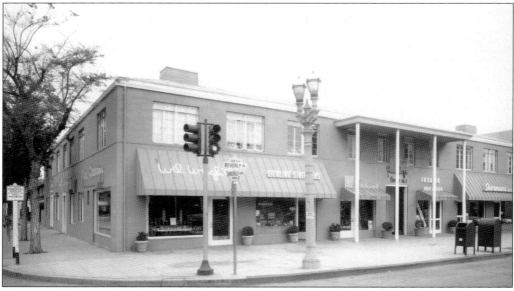

CORINNE GRIFFITH SHOPS AT FOUR CORNERS BUILDING NO. 1, 1954. Silent film star Corinne Griffith's Four Corners buildings became a landmark shopping center at Charleville and South Beverly Drive for over 65 years. Building No. 1 was built on the southeast corner in 1938. By 1948, Wil Wrights's ice cream parlor chain opened one of its stores on the corner. Building No. 3, built in 1941, today is the site of a Jamba Juice store, and Building No. 4 was the last to be built in 1949. It was occupied for many years by the Allen Wertz Candies Company, a Beverly Hills landmark itself.

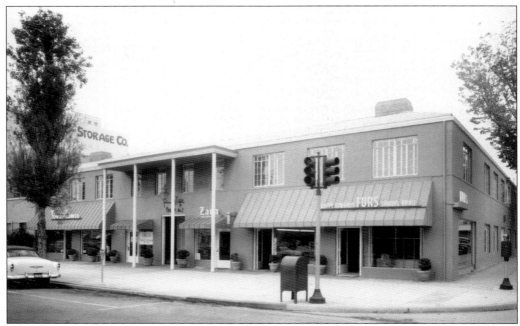

Corinne Griffith Shops at Four Corners Building No. 2, 1954. Corrinne Griffith's building No. 2 opened in 1939, and by 1954, had Town and Travel Agency, Nola Zada Custom Clothing, Duffy Edwards, Samuel Kroll Furs, and a barbershop as tenants. Since the beginning, the building was a boutique center and is today the site of the California Pizza Kitchen.

Anderton Court, 1969. Commissioned for Nina Anderton by Frank Lloyd Wright under the supervision of Joseph Fabris, the building was supposed to contain four shops. Its angular ramp winds upward in a jagged spiral. The building is a reinforced concrete, glass, and copper-textured concrete block structure. The most dynamic feature is the central apexical mast that rises above the tri-level building. The first tenants in the building included Heftler Construction Company of California, Paulette Girard Dresses, and a coiffeur. By 1969, Kazanjian Jewelers and the Klein Art Gallery were also located there.

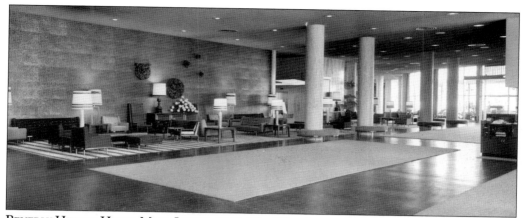

BEVERLY HILTON HOTEL MAIN LOBBY, 1963. The Hilton's main lobby, designed by Welton Becket architects, installed such features as gold-tinted reflectors designed by Marvin Manufacturing Company, which blended light with the room's color scheme. A solar lighting fixture in the elevator lobby has dimensions of 20 by 25 feet. The ceilings in the main lobby were equipped with acoustical tiles and the large open room could accommodate hundreds of people arriving or exiting the building.

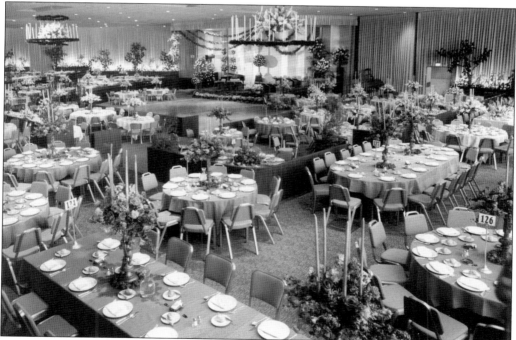

BEVERLY HILTON INTERNATIONAL BALLROOM, 1967. The Hilton's International Ballroom, with its 20,000 square feet, was the largest in the city. The room could accommodate the following: 1,750 in its reception and theater, 1,500 for banquet, and 1,300 for a dinner dance. The room has tiered seating, which can be converted to theater setting, with a permanent stage, dressing room area, and a fully professional sound and lighting system. The dance floor is hydraulically controlled, permitting it to be raised from the floor level up to the stage level. When it opened in 1956, it was state of the art. Many award shows are held here, such as the Emmy Awards and Golden Globe Awards.

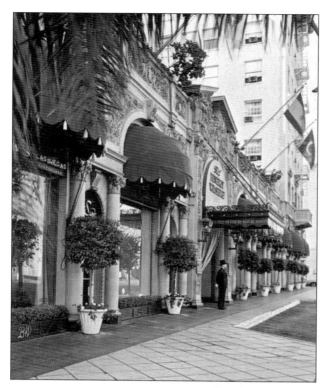

THE BEVERLY WILSHIRE HOTEL, 1963. A postcard of the Wilshire Boulevard entrance showed off the newly restored Beverly Wilshire Hotel. Owner Hernando Courtright, formerly of the Beverly Hills Hotel, announced that he was proud of the new guest rooms that "combined classic decor with the most recent developments in luxurious living appointments. Words or pictures can not adequately describe the spectacular transformation that is now the Beverly Wilshire Hotel." When Courtright took over in 1963, he introduced new dining facilities and rejuvenated the 10-story main building, which led to phase two—the erection of a 12-story annex in 1971.

THE BEVERLY WILSHIRE HOTEL LOBBY, 1963. The main hotel lobby was again renovated, this time by Hernando Courtright, who took over the hotel and wanted a combination Old World and contemporary decor giving the lobby the feeling of a living room adjacent to the front desk. The entire hotel went through several renovations from the 1930s to the 1950s, removing much of its original decor and design. The Beverly Wilshire still showed no signs of slowing down at this time, and its reputation helped make it an enduring and elegant Beverly Hills landmark.

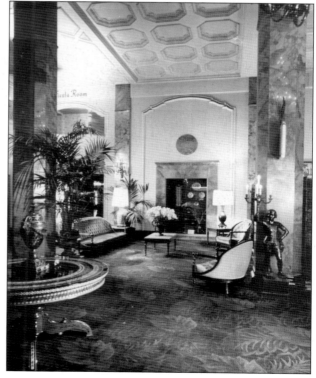

THE REGENT BEVERLY WILSHIRE HOTEL, 1991. One of Beverly Hills's most enduring landmarks, the Beverly Wilshire, at the head of Rodeo Drive, is seen here at Christmastime draped in lights. The Beverly Wilshire was acquired by Regent International in December 1985 and was completely renovated the following year. The hotel officially opened in 1989 as the Regent Beverly Wilshire Hotel. In 1992, Four Seasons acquired Regent hotels, and in 1998, another renovation was competed the following year.

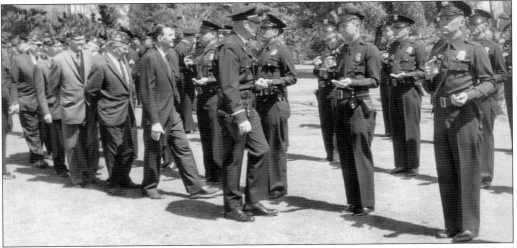

BEVERLY HILLS POLICE DEPARTMENT, 1964. A summer inspection ceremony led by police chief Clinton H. Anderson included civilians acting in an advisory capacity. Anderson was chief for 27 years and helped develop the Beverly Hills Police Department into a modern and respected police force. The uniforms were similar to that of the Los Angeles Police Department, with officers having chrome badges and cap pieces. Sergeants and officers have gold badges and cap pieces, and the buttons are gold regardless of rank.

BEVERLY HILLS CHAMBER OF COMMERCE, 1964. The chamber of commerce was organized in Beverly Hills in 1923, following its creed "to promote the economic, commercial, industrial, civic and social welfare of the people of the City of Beverly Hills." During its first 25 years, the chamber occupied nine different locations. In 1948, it acquired a property at 239 South Beverly Drive and formally opened its new office there on April 18, 1949.

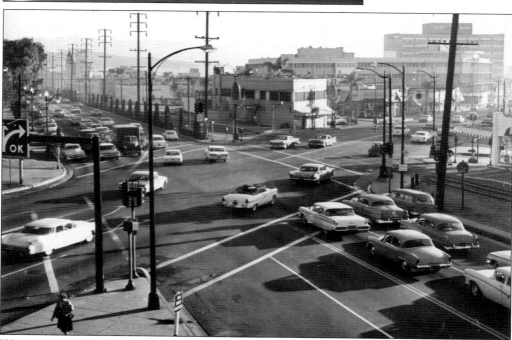

WILSHIRE AND SANTA MONICA BOULEVARDS, 1964. One of the most traveled intersections in the entire city of Los Angeles is in Beverly Hills. This intersection has always been a complicated problem due to its double intersections being so close together. Intersection No. 1 is Wilshire Boulevard and Santa Monica Boulevard, and intersection No. 2 is South Santa Monica Boulevard and Wilshire. In the 1920s, gates for the Pacific Electric railroad tracks, in operation since 1896, were installed and would block all traffic on Wilshire. For years, the railroad created traffic jams until the schedule was changed to overnight rail traffic.

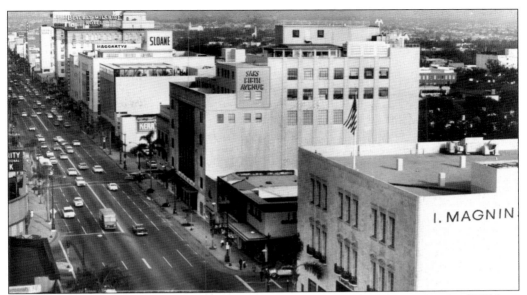

WILSHIRE BOULEVARD SHOPPING DISTRICT, 1965. In 1935, much of the south side of Wilshire Boulevard was empty lots. By 1936, W&J Sloane opened a store in Beverly Hills at 9536 Wilshire Boulevard, the first major department store in the city. In 1938, several other department stores opened branches. The famous I. Magnin and Company opened several small individual stores at 9634 Wilshire Boulevard at Bedford Drive, and in 1948, they constructed a magnificent marble-faced building. Saks Fifth Avenue opened a three-story building at 9600 Wilshire in 1938, along with the J. J. Haggarty Company.

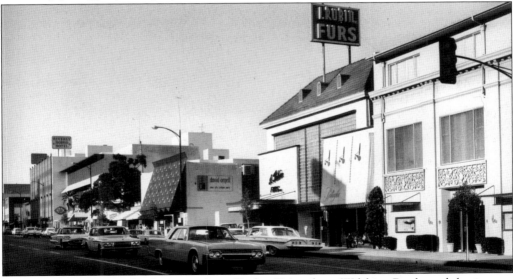

RODEO DRIVE, 1969. Looking north up Rodeo Drive from Wilshire Boulevard, businesses established in the late 1950s had expanded and modernized their stores and buildings. Rodeo Drive did not become a commercial street until late 1950 and was developed into what it is today during the 1960s. In 1969, businesses in this view of Rodeo Drive included, from bottom to top of photograph, Ruser Jewels, Battaglia Mens Clothing, I. Rubin Furs, David Orgell Silver, the Frank Lloyd Wright-Anderton Building (hidden behind trees), and the Beverly Rodeo Hotel.

GIBRALTAR SAVINGS AND LOAN, 1979. Gibraltar Savings celebrated its 50th anniversary in 1972, having been in Beverly Hills since 1922. After several locations in Beverly Hills, the site of Gibraltar Square at Wilshire and Doheny Drive opened in January 1959. At that time, a new Beverly Hills landmark was born on Wilshire Boulevard that was known, by the 1960s, as Financial Row.

WONDER BREAD FACTORY, 1968. In the early days of the Beverly Hills industrial triangle, there were a few companies in operation: the Sun Lumber Company, Payne Furnace and Supply Company, and the Holsum Bakery, which opened in 1924 and was located at 1018 Santa Monica Boulevard. At the end of the 1920s, the Continental Baking Company took over the plant at what was then 9340 Santa Monica Boulevard. Continental was a Beverly Hills landmark for over 30 years when the plant became the Hostess-Wonder Bread factory in the 1960s. For many years, residents could smell the bread baking for a mile around.

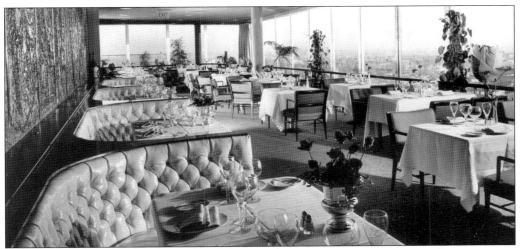

L'ESCOFFIER RESTAURANT, 1958. The main decorative attraction in the L'Escoffier restaurant was the lighted mosaic mural, installed in 1955 by muralists Dale Owen and Robert Mallory. The restaurant is on the eighth story of the Beverly Hilton Hotel with views of the city and was one of the most popular of the hotel amenities. The penthouse-level restaurant combined French food with strolling musicians, flaming dishes, and an extensive wine list when it opened. In 1991, L'Escoffier was remodeled by Merv Griffin with a new look and menu. Throughout the next decade, L'Escoffier was host to many after-award show parties such as the Golden Globes.

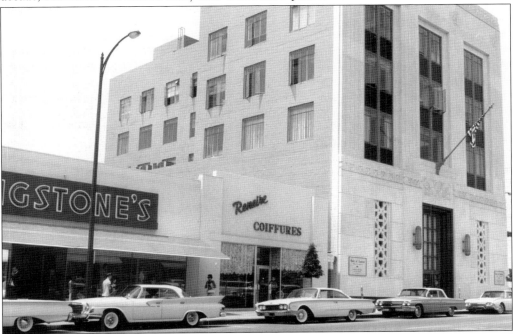

BANK OF AMERICA BUILDING, 1963. Located on the southwest corner of Beverly Drive and South Santa Monica Boulevard, the Bank of America building was the first multistoried building on Beverly Drive. Opened on February 16, 1927, the bank building at 469 North Beverly Drive was one of three branches in Beverly Hills as of 1947. The building was demolished to make way for the Museum of Broadcasting.

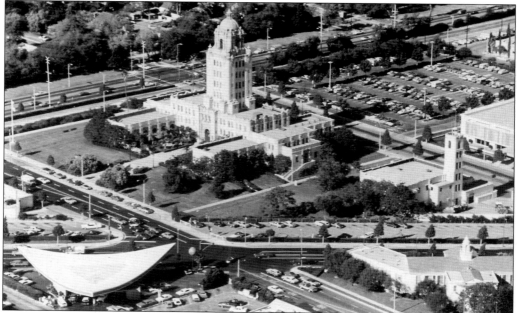

BEVERLY HILLS CIVIC CENTER, 1960. With the coming of the 1960s, the Beverly Hills Civic Center was composed of the city hall tower, police and fire departments, new public library (far right), and the post office. It would take more than 30 years before the civic center would be renovated and expanded to what it is today.

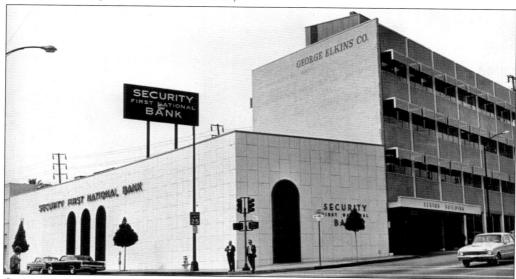

CANON DRIVE AND SOUTH SANTA MONICA BOULEVARD, 1965. The Security-First National Bank opened on the northwest corner at 469 North Canon Drive in 1922. An interesting feature of the bank's interior are three panel murals in the lobby depicting the history of El Rancho Rodeo de los Aguas (the Ranch of the Gathering of the Waters), the original Spanish land grant, which evolved into Beverly Hills. The George Elkins Real Estate Company building was built in 1960 on the site of the second Pacific Electric railway station in Beverly Hills, the first being on the site of the post office across the street.

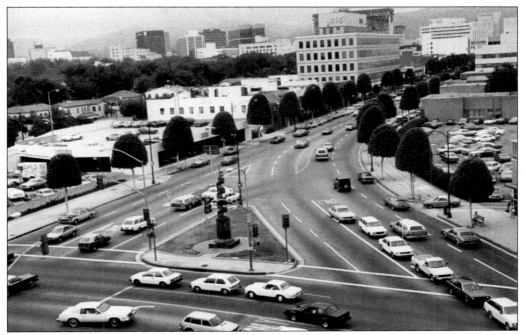

SOUTH BEVERLY DRIVE LOOKING NORTH FROM OLYMPIC, 1983. In the center of this intersection is a memorial entitled *Celluloid*, dedicated in 1959 to honor those movie star residents who worked in 1923 "for the preservation of Beverly Hills as a separate municipality." Among the stars represented on the monument are Douglas Fairbanks, Corinne Griffith, Conrad Nagel, Mary Pickford, and Will Rogers.

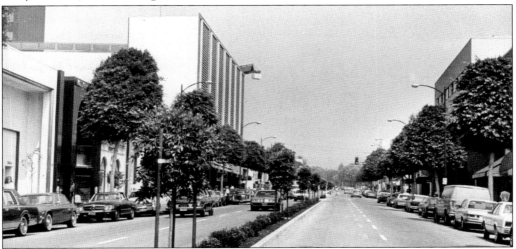

RODEO DRIVE, 1982. It was around 1954 that the Rodeo Drive known today was in a state of development. Some of the first merchants on the street included David Orgell, Carroll and Company, the Luau Restaurant, and the Brown Derby. Later Gucci, Giorgio, Van Cleef, Arpels, Armani, and many others joined the earlier merchants. In 1982, the Rodeo Collection opened as a four-story courtyard shopping complex erected on the site of the Luau. Louis Vuitton, Fendi, Nina Ricci, Tommy Hilfiger, Ungaro, and Versace all opened stores there. In 1985, Chanel opened a branch store, and in 1988, Girogio Armani added a store to the street.

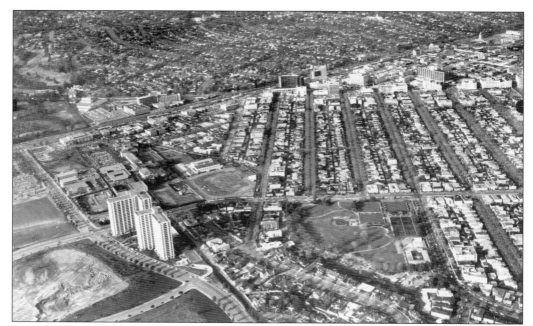

BEVERLY HILLS LOOKING NORTH, 1967. In the bottom left of this photograph is the continuing development of Century City, bottom center is Roxbury Park, upper left is Robinson's and the Hilton Hotel, and upper right is the Beverly Hills commercial triangle between Santa Monica and Wilshire Boulevards.

UNION 76 SERVICE STATION, 1989. Located on the southwest corner of Crescent Drive and South Santa Monica Boulevard, the station with its unique 1950s single-wing design was symbolic of flight. Built in 1958, the design was for a station near Los Angeles International Airport, but it was built in Beverly Hills instead. With its florescent signature lighting, the station at night is an unusual artistic sight at the intersection next to the Beverly Hills Civic Center. Since the station opened, it has become another of Beverly Hills's most impressive landmarks.

GIORGIO'S BEVERLY HILLS BOUTIQUE, 1985. Giorgio's, originated by Fred Hayman at 273 North Rodeo Drive in the early 1960s, became the most famous store on Rodeo. By 1972, the distinctive yellow and white awnings became a trademark and the slogan, "Beverly Hills Most Distinguished Shop for Well Dressed Women & Men," was born. In 1979, Hayman developed a signature fragrance for Giorgio, which became an international success in 1981. In 1987, Hayman sold Giorgio Beverly Hills to Avon, and he subsequently renamed the store on Rodeo Drive Fred Hayman Beverly Hills. In 1998, Fred Hayman vacated the store and leased it to the Louis Vuitton Company.

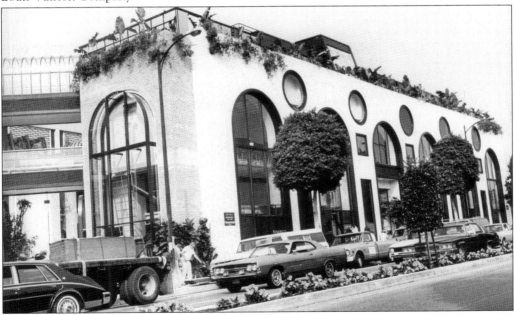

RODEO COLLECTION, 1982. Located on the site of the famed Luau restaurant, the five-tiered, open-air shopping center with landscaped sunken gardens was developed to house 40 to 50 shops with underground valet parking. The architectural details of the project included marble, limestone, brass, and brick. In its early days, companies such as Louis Vuitton, Nina Ricci, Givenchy, Chanel, and Versace opened stores. Although many of these left the complex for larger stores, other companies filled the void after several years of vacancies. By 1997, some of the stores located in the complex included Versace, Kronos, Bakarat, and Bijan Fragrances.

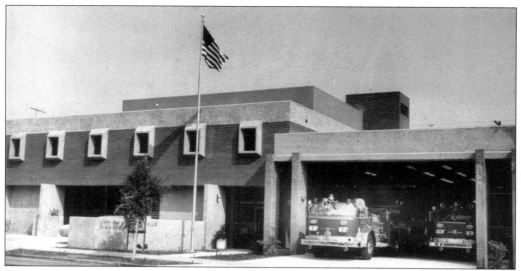

BEVERLY HILLS FIRE STATION NO. 3, 1972. Located at 180 South Doheny Drive, just south of Wilshire Boulevard, this station opened in April 1972 and filled the need for fire protection in the southeast section of Beverly Hills. Beverly Hills up to that point had only three stations that handled much of the city. Station No. 1 is located at city hall, and Station No. 2 is located in Coldwater Canyon.

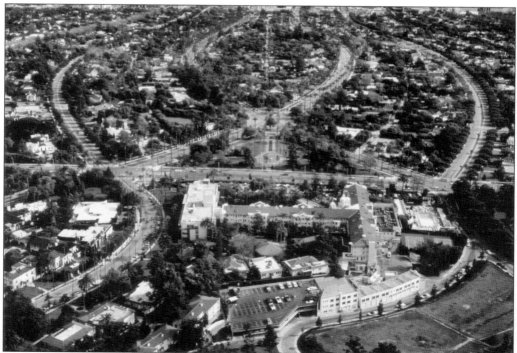

BEVERLY HILLS LOOKING SOUTH, 1972. An overview of the Beverly Hills Hotel south to the business triangle shows the beautiful curved city street grid system that was designed by prominent landscape architect Wilbur Cook in 1907. Will Rogers Memorial Park is the triangular park where Beverly, Crescent, and Lomitas Drives meet.

RAILROAD RIGHT-OF-WAY AT SANTA MONICA AND BEVERLY BOULEVARDS, 1976. Original eucalyptus trees still line the old Pacific Electric Railway right-of-way where Beverly Boulevard merges with Santa Monica. The rail system was completed through the area of what was to become Beverly Hills in 1896. Shortly after the turn of the 20th century, the Los Angeles Pacific Electric announced the Balloon Route, a railway trip throughout the Los Angeles area that ran directly through West Hollywood, Beverly Hills, and West Los Angeles. After the demise of the trolley system in Los Angeles, freight trains used these tracks until 1965.

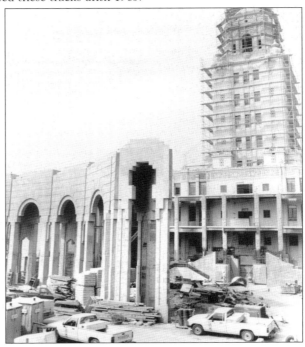

NEW CIVIC CENTER CONSTRUCTION AND RESTORATION, 1989. The design for the new Beverly Hills Civic Center additions was created by Charles Moore, UCLA professor of architecture and urban planning in 1982. The project of expanding new facilities and restoring the original buildings began in 1983 and continued until completion in 1990. The project included expansion of the public library, construction of new parking structure, new fire and police department buildings, and expanded office space in the original city hall tower.

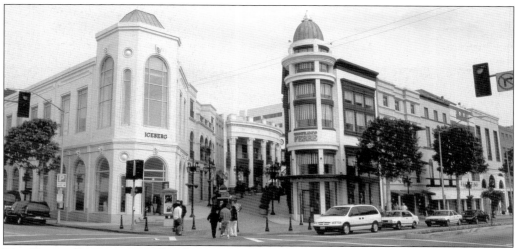

TWO RODEO DRIVE, 1997. The elegant retail complex on the northeast corner of Rodeo Drive and Wilshire Boulevard opened in September 1990 as Two Rodeo Drive. The European inspired, three-story retail development with a pedestrian street running through it became the newest of the Beverly Hills landmarks at the beginning of the 1990s. The first tenants in the complex included Cartier, Tiffany, Christian Dior, Charles Jourdan, Valentino, and Sulka. By 2000, a European trust company purchased the Japanese company's investment in Two Rodeo Drive. By 1997, Versace and Iceberg opened stores in the complex.

BEVERLY HILLS FIRE STATION NO. 2, 2005. In 1925, the Beverly Hills Fire Department became a separate entity along with other city services at the newly built headquarters at Burton Way and Crescent Drive. At this time, Lloyd B. Canfield became the city's first fire chief. It was Canfield that built two additional fire stations in the growing city. Station No. 2 originally opened at the mouth of Coldwater Canyon at 1016 North Beverly Drive in 1928 and was completely replaced in the 1980s. Station No. 3 originally opened on Robertson Boulevard and Gregory Way around the same time, and in 1972, reopened in a new facility on Doheny Drive.

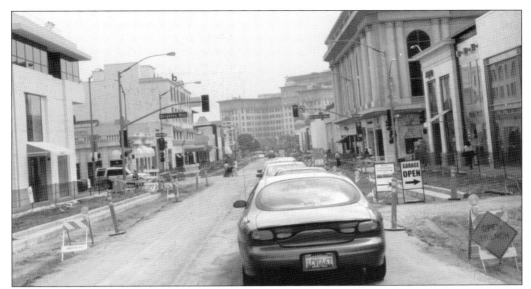

RODEO DRIVE RECONSTRUCTION, 2003. Early in the 21st century, Rodeo Drive was in need of some major renovation to turn the shopping street into something different and stimulating. A plan to widen the major sidewalks and streets such as Canon, Beverly Drive, and Rodeo Drive in the commercial triangle was started in early 2003 and was finished by Christmas.

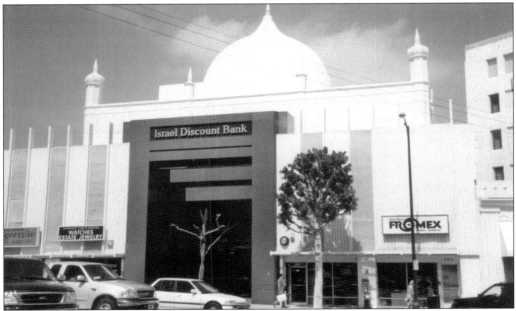

BEVERLY THEATER, 1999. The East Indian–style theater was built by Beverly Hills real estate pioneer Dan M. Quinlan and designed by L. A. Smith in 1925. It was Beverly Hills's first motion picture film theater, located on the northeast corner of Beverly Drive and Wilshire Boulevard. By 1977, the theater closed, and it was remodeled into the famous Fiorucci clothing store in 1980. By the mid-1980s, the Israel Discount Bank completely renovated the building, leaving only the roof decorations and onion dome intact. In late 2005, the theater building was completely demolished to make way for the future Montage Hotel project.

ACROSS AMERICA, PEOPLE ARE DISCOVERING SOMETHING WONDERFUL. *THEIR HERITAGE.*

Arcadia Publishing is the leading local history publisher in the United States. With more than 3,000 titles in print and hundreds of new titles released every year, Arcadia has extensive specialized experience chronicling the history of communities and celebrating America's hidden stories, bringing to life the people, places, and events from the past. To discover the history of other communities across the nation, please visit:

www.arcadiapublishing.com

Customized search tools allow you to find regional history books about the town where you grew up, the cities where your friends and family live, the town where your parents met, or even that retirement spot you've been dreaming about.